AMERICAN
WORKS ON PAPER
III

Winter 1989

SPANIERMAN/DRAWINGS

Betty Krulik, Director

By appointment 50 East 78th Street New York, NY 10021 Telephone (212) 879-7085 Fax (212) 249-5266

© 1989 Spanierman/Drawings

Design: Marcus Ratliff Inc.
Composition: Trufont Typographers
Lithography: Eastern Press

ISBN: 0-945936-05-2

Aمerican Works on Paper III presents seventy-four drawings, watercolors and pastels created by American artists of the nineteenth and twentieth centuries. Reflecting the broad diversity of our art historical heritage, this catalogue includes works created in an extremely wide range of styles and rendered in a great variety of different techniques. We are very pleased to make it available to you.

Many members of the Spanierman Gallery staff contributed their time and effort to this publication. We would especially like to thank Suzanne Meadow and Betsy Arvidson for their valuable organizational skills. David C. Henry and Ellery Kurtz shared their knowledge and provided superb guidance. Carol Lowrey skillfully edited bibliographic citations. We are also grateful to Marcus Ratliff and his staff for designing and producing this catalogue, and to David Sassian who prudently edited the entries.

Ira Spanierman
Betty Krulik

American Works on Paper III introduces a new format; each work is accompanied by an essay written by members of the Spanierman Gallery staff or by outside scholars who are identified below.

Spanierman Gallery staff contributors:

| LB | Laurene Buckley | CL | Carol Lowrey | LP | Lisa N. Peters |

Other contributors:

BB	Betsy Boone	RB	Richard Boyle	RC	Ronny Cohen
NEG	Nancy Green	SH	Susan Hobbs	BJM	Barbara J. Mitnick
PN	Percy North	AJP	April J. Paul	DS	David Sellin

CAROLINE VAN HOOK BEAN (1879–1980)

1. *Orchard Street*, 1918

Watercolor, gouache and pencil on toned paper
18¼ × 13 inches
Signed, dated and inscribed lower right: *Orchard Street / Sept. 1918 /*
 Caroline van H. Bean

PROVENANCE
Private Collection, New York

FOLLOWING HER GRADUATION from Smith College in 1903, Caroline van Hook Bean studied under William Merritt Chase at the New York Academy, where her classmates included George Bellows, William Glackens and Eugene Speicher. During her stay in London she also received criticism from John Singer Sargent. In the 1940s Bean settled in Washington, D.C., her native city.

Bean's association with several Ashcan School artists during her student years is reflected in her interest in urban subjects. In *Orchard Street*, one of a series of works that depict New York City in wartime, she expresses the animated and picturesque qualities of the Lower East Side tenement district. Executed at the time of the fourth Liberty Loan drive in September 1918, the work conveys the festive atmosphere at the home front that could be seen at this point during the war when elaborate decorations were hung in patriotic displays. Here, flags slung on wires crisscross over the narrow street, and extend from balconies where they mingle with the laundry hung out to dry. The street below is carnival-like, as vendors with pushcarts filled with produce barter their goods to passers-by. Through her choice of a vertical format, Bean heightens the feeling of crowding and intense activity.

Exhibited in 1919, Bean's wartime series was received as a "brilliant and joyous show," demonstrating the artist's "fine sense of color and form."[1] Using impressionist brushwork and sparkling color to expressive ends, Bean conveys, as did Childe Hassam in his flag paintings, an American attitude of optimism and patriotism at the time of World War I.

L.P.

1. Frederick James Gregg, "Miss van H. Bean Paints New York in Wartime," *New York Herald*, 9 February 1919, p. 8.

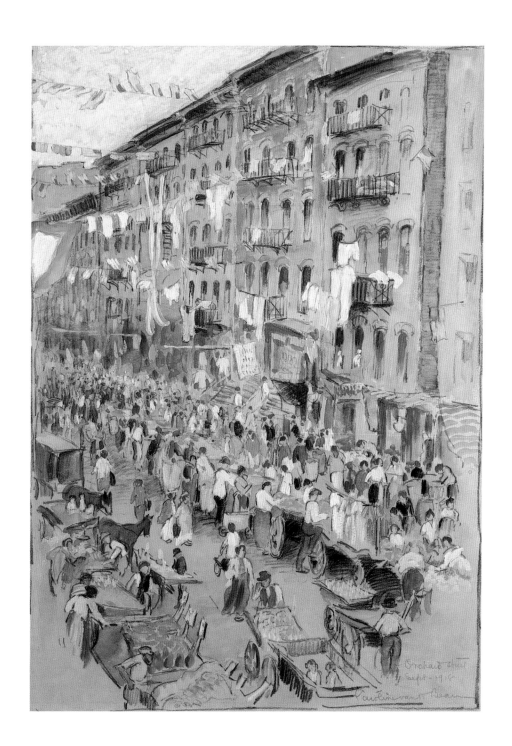

THOMAS HART BENTON (1889–1975)

2. *Utah Desert*, 1951–1953

Gouache on paper
13 × 17½ inches
Signed and dated lower right in ink: *Benton '51*
Signed and dated lower right in pencil: *Benton '53*

PROVENANCE

The artist
[Graham Gallery, New York]
Private Collection, St. Louis, Missouri

EXHIBITED

Marion Koogler McNay Art Institute, San Antonio, *Collectors Gallery
XII*, 10 November–26 December 1978

THOMAS HART BENTON shared with the other major figures of
American Regionalism, Grant Wood and John Steuart Curry, a
Midwestern birth and orientation and an innate ability to commit
the rural, agrarian and Western subject to canvas.

Benton was born in Neosho, Missouri, in 1889, the great-nephew of
the state's first senator and the son of a congressional representative. He
attended art classes at the Corcoran Gallery of Art in Washington, D.C.,
and later at the Chicago Art Institute before sailing for Paris in 1908,
where he enrolled at the Académie Julian and the Académie Colarossi.
After meeting Stanton Macdonald-Wright and Morgan Russell, Benton
joined their Paris-based Synchromist movement. When he returned to
America in 1912, he was working in a style that combined Synchromist
ideas with influences derived from his study of the Italian Renaissance
masters. By the mid–1920s, however, he had become one of the country's
foremost advocates of realism, celebrating subjects from American history
and contemporary life in both easel and mural-size compositions.

In 1934, a joint exhibition of Benton, Wood and Curry catapulted
the triumvirate to fame. That same year, Benton returned to his native
Missouri, where he painted some of his major murals for public
institutions. He also traveled throughout the Midwest, South and Far
West looking for new subjects. The little known body of work inspired by
these trips includes *The Sheepherder* (1955–1960; Private Collection),
Lewis and Clark at Eagle Creek (1965; Private Collection) and a number
of pure landscapes, including *Utah Desert*, a gouache drawing on paper

from 1951–1953. In this work, the artist leads the viewer through intricate
layers of undulating hills to a stylized mountain range in the distance.
Every clump of sagebrush, each wind-swept tree and each curve of
eroded land mass is in motion, rendered with Benton's typical verve and
expressionistic brushwork.

Eschewing the intense coloration of the desert, Benton opts for the
cool, monochromatic tones of gray and white, a maneuver often used by
artists to establish value contrasts. *Utah Desert* recalls the exaggerated
landscape imagery of Flemish painting, which had been introduced to
Benton by Wood, but the linear gesture, pulsating rhythm and pure joy in
the experience of the Western landscape make it uniquely the work of
Thomas Hart Benton.

L.B.

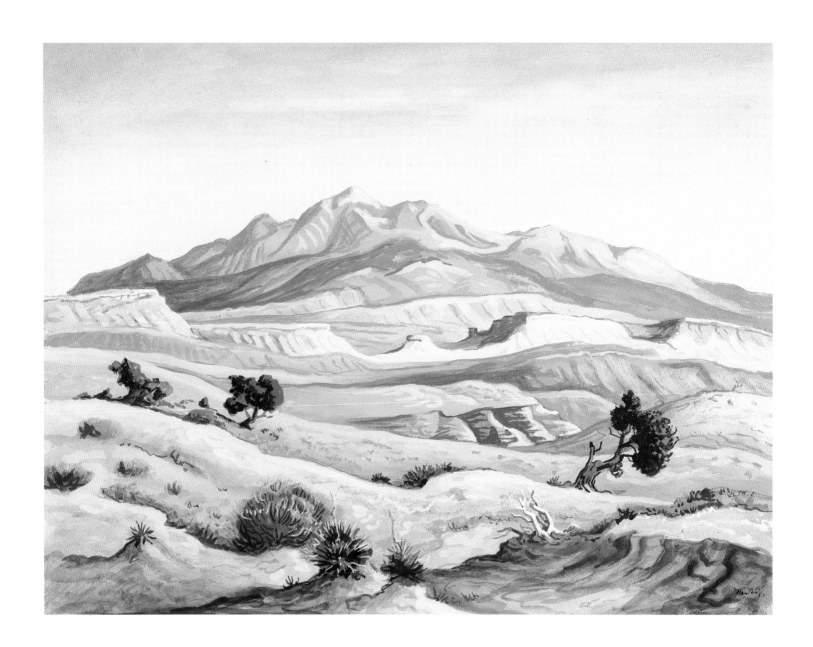

Emil Bisttram (1895–1976)

3. *Composition No. 40*, ca. 1955

Charcoal on paper
12½ × 20½ inches
Signed lower right: *Emil Bisttram*

PROVENANCE
Estate of the artist
Wife of the artist
Private Collection, New Mexico

EMIL BISTTRAM was born in Hungary and came to the United States at age seven. His early studies were at the National Academy of Design, Cooper Union, and the New York School of Fine and Applied Art. Conceptually, Bisttram belongs to the generation of American artists that came after the pioneering modernists; Marsden Hartley, Arthur Dove, Abraham Walkowitz and Georgia O'Keeffe, and before Willem de Kooning, Mark Rothko and Adolph Gottlieb, and other early Abstract Expressionists. Like his contemporaries Stuart Davis and Carl Holty, Bisttram was a modernist with a mission: to break the hold of the conventional modes of realism and illustration that dominated the American art scene. By the time he settled in Taos, New Mexico, in the early 1930s, Bisttram had fixed on this mission, which he pursued not only through his art but also through teaching and lecturing.

Composition No. 40 is a stirring, suggestive abstraction that exhibits both Bisttram's concern for theoretical principles of design and his respect for the instinctual sources of creation. While enigmatic shapes bear some resemblance to the imagery found in Adolph Gottlieb's "Pictographs" of the late 1940s and early 1950s, their vitality marks them as independent products of Bisttram's imagination. In stressing contrasts of black and white and in unifying the work through compound linear rhythms and the movement of faceted planes, Bisttram shows how thoroughly he had assimilated his earlier studies of "dynamic symmetry," the analytical system of design that was the invention of Jay Hambidge, an artist active in the early decades of the century.

In its evocation of metaphysical dimensions of spirit, *Composition No. 40* also demonstrates how well Bisttram was able to realize in his mature work the aims—not unlike those of the Abstract Expressionists—of the Transcendental Painting Group, the forward-looking association of New Mexico artists he had helped organize in 1938.

R.C.

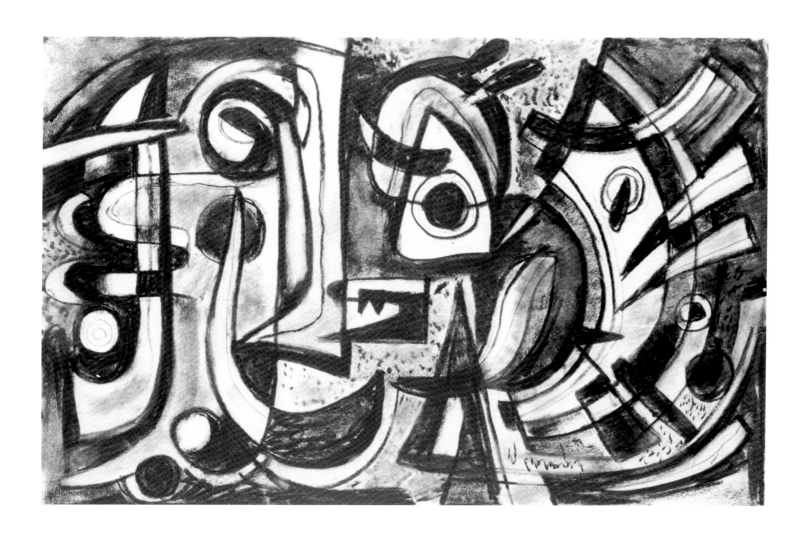

EDWIN HOWLAND BLASHFIELD (1848–1936)

4. *Pensive*, ca. 1910

Red conte crayon on paper laid down on board
28 × 21¼ inches
Signed and inscribed lower left: *To Emily Cass Gilbert / Edwin Howland Blashfield*

PROVENANCE
Emily Cass Gilbert
Private Collection, New York

EXHIBITED
American Academy of Arts and Letters, New York, *Exhibition of the Works of Edwin Howland Blashfield* 10 November 1927–1 April 1928, cat. no. 242.

the figure in oil, pastel and drawings. *Pensive*, executed in red conte crayon against a cream-colored background, shows Blashfield's skill as a draftsman. The unidentified model rests her chin on her left arm as she gazes into the distance, seemingly preoccupied with her thoughts.[1] Her hair is bound in a web of ribbon, a motif derived from the art of classical antiquity, from which Blashfield, and many of his contemporaries who worked in the "grand style," took inspiration.

The sitter's finely modeled heart-shaped face, with its full lips and rounded jaw, is devoid of apparent emotion. Yet her concentrated stare, her self-awareness and her aloof bearing reveal an intense intellectual activity from which we are excluded. Thus, although *Pensive* functions to some extent as a portrait of an individual, insofar as it portrays an ideal female, it also reveals that Blashfield's conception went well beyond the traditional qualities of beauty and innocence to encompass confidence, poise and intelligence.

C.L.

OFTEN REFERRED TO as the "dean of American mural painters," Edwin Howland Blashfield was one of the foremost exponents of academic realism at the turn-of-the-century. An influential figure in New York art life, Blashfield was a member of such organizations as the Society of American Artists, the American Society of Painters in Pastel, the National Society of Mural Painters, and the National Academy of Design, for which he served as president from 1920 until 1926.

Blashfield studied in Paris under Léon Bonnat from 1867 until 1870 and again from 1874 until 1880. He also received informal criticism from Jean-Léon Gérôme, one of the most prominent artist-teachers of the day. Inspired by Gérôme's emphasis on solid draftsmanship, carefully constructed compositions and the accurate portrayal of detail, Blashfield painted historical genre scenes as well as religious and allegorical subjects.

After receiving his first decorative commissions in the late 1880s, Blashfield began to devote the majority of his time to mural painting. His most notable projects included decorations for the World's Columbian Exposition in Chicago (1893) and the dome of the Library of Congress, both of which brought him widespread national acclaim. Blashfield was also active as an illustrator and a writer, often collaborating with his wife, the author Evangeline Wilbour.

Like other artists of his *milieu*, Blashfield frequently combined aspects of Renaissance allegory with representations of ideal female types and despite his commitment to mural painting, he continued to explore

1. The inscription "To Emily Cass Gilbert" refers to Emily Finch Gilbert (1889–1962), daughter of the noted architect Cass Gilbert (1859–1934), who designed the Woolworth Building in New York. Blashfield and Gilbert, friends and professional collaborators for many years, held similar aesthetic outlooks, each believing in the unity and harmony of architecture, painting and sculpture. Blashfield provided mural decorations for several of Gilbert's buildings, including the Minnesota State Capitol in St. Paul, the Essex County Courthouse in Newark, New Jersey and the Detroit Public Library.

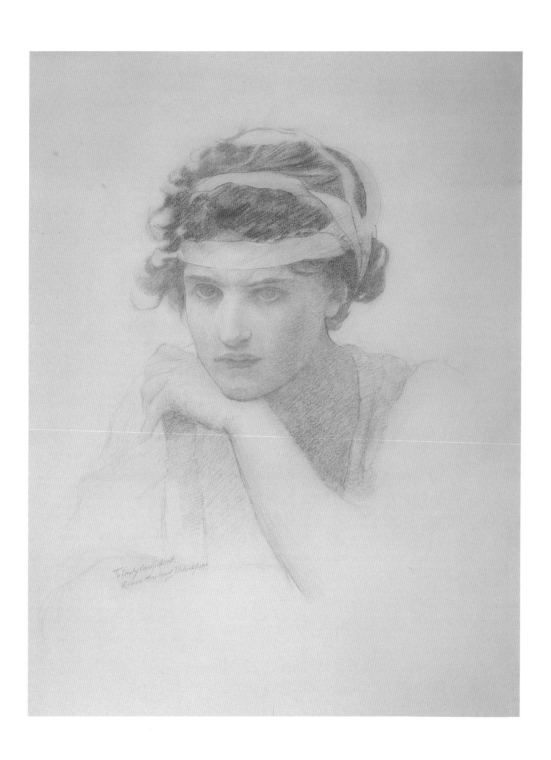

ROBERT FREDERICK BLUM (1857–1903)

5. *Piazza San Marco, Venice*, 1881

Watercolor and pen and ink on paper
7½ × 11½ inches
Signed, inscribed and dated lower center: *Blum 1881/To Flora*

PROVENANCE
Flora de Stephano, Blum's girlfriend
Mullins Family Collection, Florida
Private Collection, New York

ONE OF THE MOST prominent artists of his day, Robert Blum created works in a great number of media and explored a wide range of technical and aesthetic issues. He began his art education in his native Cincinnati, receiving instruction at the McMicken School of Design and under Frank Duveneck. During a visit to the Philadelphia Centennial Exposition in 1876, Blum saw and was greatly affected by the work of the Spanish artist Mariano Fortuny, whose aesthetic he was to emulate throughout his career. James McNeill Whistler, whom Blum met during the summer of 1880 in Venice, was the other major influence on him, and in the development of his mature style Blum reconciled aspects of the two artists' approaches.

During the 1880s, Blum became president of the Society of Painters in Pastel, and along with his colleague in the New York organization, William Merritt Chase, he helped to increase public awareness of the pastel medium. Blum is also well known for his depictions of Japanese subjects. He traveled to Japan in 1889 on assignment for *Scribner's Magazine* to illustrate *Japonica*, a book by Sir Edwin Arnold. During his two year stay in the country, he executed some of his finest pastels.

Created in 1881, *Piazza San Marco, Venice* reflects the strong impact of Whistler on Blum during the period following his trip to Venice. The work depicts the most well known site in Venice, the famous trapezoidal square facing the Basilica of Saint Mark, a scene rendered by countless artists. Blum avoids the pomp and the history associated with the square, instead focusing on the fugitive moment. Like Whistler, he eschews a literal transcription in favor of a more abstract expression. Through a balance of horizontal and vertical elements, he accentuates the pictorial surface as in a Japanese print. Leaving his paper blank over most of the work, he uses its soft white tone to convey the misty quality of the air, the hazy atmosphere within which forms of passers-by and buildings seem to

dissolve and reemerge. In suggesting the slow pace of life in the square, he renders figures as dark vertical marks that draw the eye gradually into the distance. Despite the work's overall abstractness, many of the details are depicted with refined suggestion. Pigeons fluttering down to receive bread crumbs are rendered with soft washes lightly rubbed in. The domes of Saint Mark's, executed with sketchy yet confident strokes, glisten and entice in the distance. Inscribed to his girlfriend, Flora de Stephano, Blum's *Piazza San Marco, Venice* conveys the poetic and magical spectacle that Venice presented, the romance inherent in the everyday life of the city.

L.P.

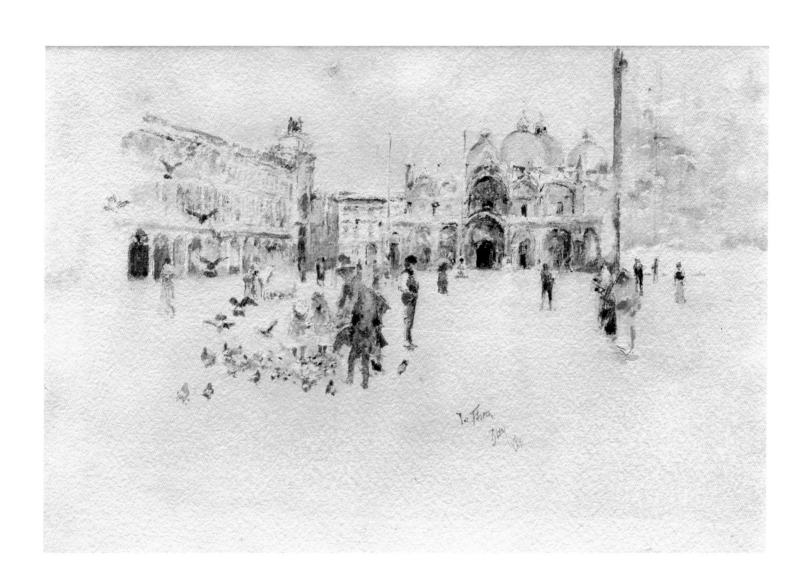

ALFRED THOMPSON BRICHER (1837–1908)

6. *Morning Along the Coast*, ca. 1880

Watercolor and gouache over pencil on paper
10¾ × 27 inches
Signed lower right: *ATBricher*

PROVENANCE
Private Collection, New York

DURING HIS FIFTY-YEAR career Alfred Thompson Bricher was constantly on the go, leaving the studio, he kept first in Boston and later in New York City, for several weeks to months at a time in search of locations that held his visual interest. He traveled most often in Rhode Island, Massachusetts and New York. A firm believer in the aesthetic insights gained from sketching on the spot, he is known to have pursued this activity with enthusiasm and vigor despite the physical discomforts involved.

Morning Along the Coast, one of Bricher's finest New England coastal scenes, might well have been inspired by a trip to the Narraganset and Point Judith sections of Rhode Island, areas to which he frequently returned in the 1870s and 1880s. It is a striking example of his mastery of the panorama, one of the most difficult of landscape formats, owing to the inherent spatial complexities. With a few rapid pencil strokes visible under the layers of watercolor along the horizon, Bricher sets up the sophisticated planar structure of the composition. He subtly leads the eye through the near, middle and distant views, creating a vivid impression of the enveloping natural world. Through tonal effects he conveys the rich tapestry of elements within this encompassing beauty, from the reflective surface of the water to the intricate configuration of a single stone.

The painting shows Bricher to be a leading representative of the Hudson River School traditions that were carried forward by the luminist currents so important to American landscape art of the second half of the nineteenth century. Like Martin Johnson Heade, the artist to whom his work invites close comparison, Bricher is able to bring forth in realistic images of startling clarity the expressive essence of nature. With the addition of the human details—the sailing ships far out on the horizon and the fisherman closer to shore—Bricher is sounding a thematic note concerning the human need to be at one and at peace with nature.

R.C.

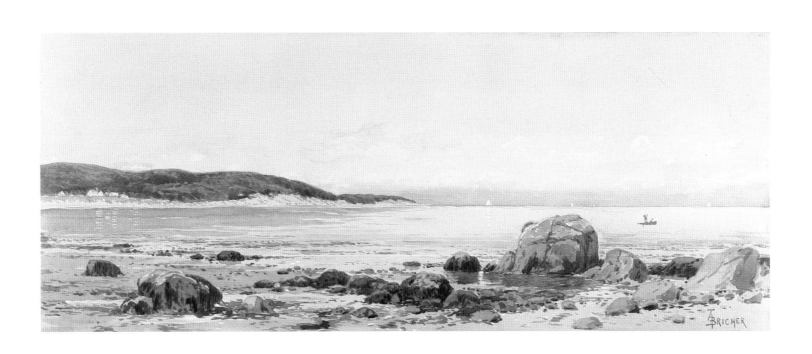

BYRON BROWNE (1907–1961)

7. *Circus Figures*, ca. 1946

Watercolor and gouache over pencil on paper
19½ × 24½ inches
Signed lower right: *Byron Browne*

PROVENANCE
Private Estate, New York State

BYRON BROWNE was born in 1907 in New York City. His first artistic training was at the National Academy of Design, where he studied from 1925 to 1928 under Charles Hinton, Charles Hawthorne, Charles Courtney Curran and Ivan Olinsky. His work of this period was conventional; in 1928, however, he destroyed much of his early work in a rejection of academicism.

Around the same time, Browne met Arshile Gorky, who introduced him to abstract art. During the 1930s he worked on abstract collages, and in 1933 he was given a one-man show at the Whitney Museum of American Art.

A keen sense of showmanship will be one of the things for which Samuel Kootz, who from 1945 until the early 1960s directed one of the most progressive art galleries in New York, will be remembered. Byron Browne and other members of the elite Kootz stable, including William Baziotes, Romare Bearden, Adolph Gottlieb and Robert Motherwell, participated in Kootz's well-publicized theme show, *The Big Top* (opening on March 3, 1946), which presented examples of each artist's interpretation of circus imagery. For this exhibition Browne executed dozens of oils and works on paper portraying clowns, jugglers, bareback riders, animal trainers and acrobats caught in a moment of time.

The brightly hued, lively *Circus Figures* dates from this period and depicts various circus artists performing their speciality acts. Except in the two center panels of harlequin trapeze artists, which evoke Picasso's circus-family paintings of 1905, Browne's dominant performer is a female, always his favored subject. In the upper-left panel she is the acrobat balancing on her harlequin's shoulder; she is posing on a giant ball in the lower left; riding atop a horned bull's head in the lower right; and, above, tumbling off her acrobatic partner's back. These pictures demonstrate Browne's ability to combine Cubist inflections with decorative design elements—circles, color bars, multiple arabesque lines (often scratched into the wet surface), starbursts and dense, Miró-like squiggles—that fill the entire figure and spill onto the background in phantasmagorical patterns.

The athletic poses portrayed in this unusual six-panel study also provided the basis for many of the later circus paintings on canvas, an important series in his career. By placing flourishes of concentric circles beside his signature in the space between the center and lower right panels, Browne indicates he meant this study to stand on its own as a discrete work.

A.J.P.

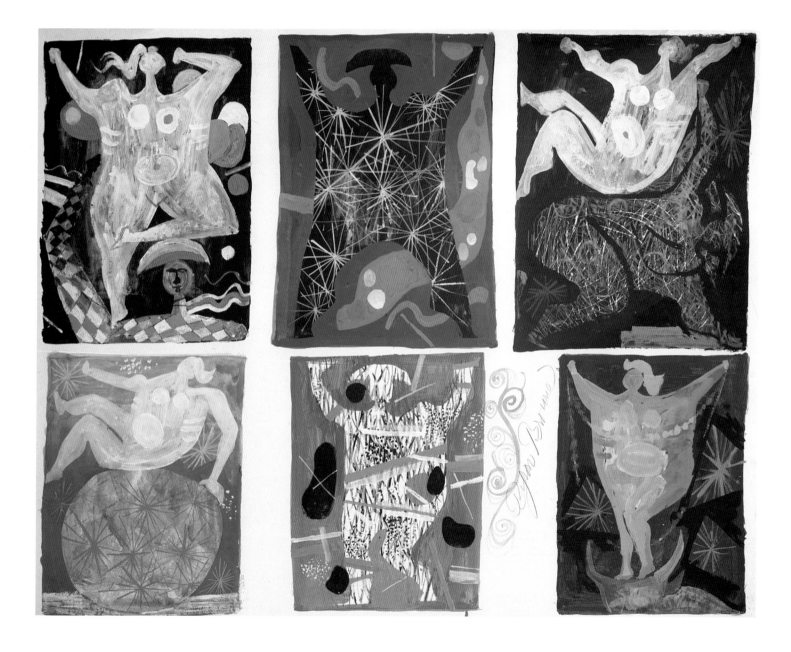

ALEXANDER CALDER (1898–1976)

8. *Cowboy with Horse in a Lasso*, 1932

Pen and india ink on paper
22 × 30 inches
Signed and dated lower right: *Calder 1932*

PROVENANCE
The artist
[Perls Galleries, New York]
Roland Meledandri, New York
Mrs. Roland Meledandri, New York

ALEXANDER CALDER, a sculptor of international renown, was born in Philadelphia in 1898. He came from an artistic family; both his father and grandfather were accomplished sculptors who produced heroically scaled, figurative monuments.

After receiving a degree in mechanical engineering from Stevens Institute of Technology in Hoboken, New Jersey, Calder traveled for the next four years and held a variety of jobs, all engineering related. He took an evening drawing class in 1922 and the following year enrolled at the Art Students League where his father, John Sloan and Boardman Robinson were teaching.

Two weeks of sketching at the 1925 Ringling Brothers and Barnum & Bailey Circus, on commission for the *National Police Gazette*, produced a unique series of circus drawings that were published as *Animal Sketching* in 1926, the same year that Calder left for a stay in Paris. There he began to create and perform with his miniature, animated wire circus to appreciative audiences from the international art world. In 1926, he also began his first independent wire sculptures; his *Brass Family* (1927; Whitney Museum of American Art, New York), *Horse* (ca. 1928; Whitney Museum of American Art, New York) and *Varése* (1931; Whitney Museum of American Art, New York) are all masterpieces in this media.

Calder created a remarkable series of ink drawings in 1931 and 1932, many of which relate in both theme and linear quality to his famous three-dimensional circus. Another subject in this series, related in terms of spectacle and the centrality of animals, is seen in Calder's rodeo scene, *Cowboy with Horse in a Lasso*.

Using the purity of the paper for both desert and sky, the artist inhabits the scene with only the simple contour lines of a cowboy, a horse, a cactus plant and a row of distant hills. He weaves the main characters by threading the circular lines of the lasso in a springlike fashion from cowboy to horse. With only the slight suggestion of a landscape to give spatial scale, it is not difficult to imagine the figures as two of Calder's x-rayed wire creatures, alive with movement and grace. It is "from the spaces, the silences in his works," one admirer wrote, "that life springs out at us."[1]

Cowboy with Horse in a Lasso draws on the "spaces" and "silences" Calder admired in the paintings and drawings of his Parisian friends, Jules Pascin, Joan Miro and Hans Arp, yet his ability to infuse the drawing with a personal style of humor and a delicate balance true to his engineering background, demonstrates the uniqueness of Alexander Calder's world.

L.B.

1. Arthur Miller quoted in *Alexander Calder: 22 July 1898– 11 November 1976*, exh. cat. (New York: Whitney Museum of American Art, 1976), n.p.

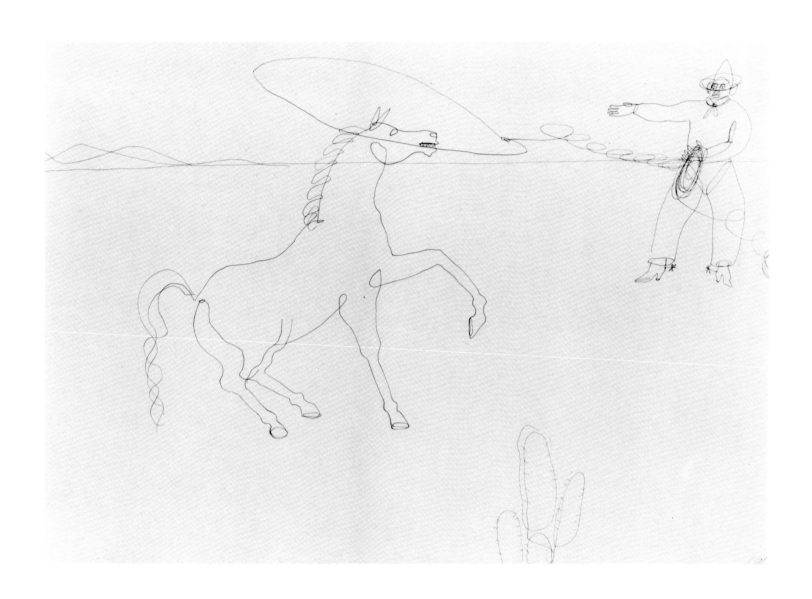

MARY CASSATT (1844–1926)

9. *Margot's Head*, ca. 1902

Pencil on paper
16 × 12¼ inches
Stamped lower left center: *Mathilde X collection*

PROVENANCE
Acquired from the artist by Mathilde Vallet, 1927
Mathilde X Sale, Paris, 1931

EXHIBITED
Galerie A.M. Reitlinger, Paris, 1931, cat. no. 162, illustrated.

LITERATURE
Adelyn Dohme Breeskin, *Mary Cassatt: A Catalogue Raisonné of the Oils, Pastels, Watercolors, and Drawings* (Washington, D.C., Smithsonian Institution Press, 1970), p. 289, cat. no. 873.

MARY CASSATT was the only American artist officially associated with the French Impressionists. Talented, dedicated and independent in spirit, Cassatt drew widespread critical acclaim for her penetrating studies of modern women and her fresh, spontaneous renderings of mothers and children. Cassatt also played an important role as an advisor to such American collectors as Mrs. Potter Palmer and Louise and Horace Havemeyer, urging them to purchase art by Old Masters and the French avant-garde.

Born in Allegheny City, Pennsylvania, near Pittsburgh, Cassatt began her art instruction at the Pennsylvania Academy of the Fine Arts, where she studied from 1861 until 1865. In 1866 she went to Paris, studying in the *ateliers* of Charles Chaplin and Jean-Léon Gérôme. On later trips to Italy, Spain, Belgium and Holland, she studied and copied the works of Correggio, Parmigianino, Hals, Velasquez and Rubens.

Cassatt began exhibiting at the Paris Salon in 1868. Her early work was dark and sombre in tone. However, as her dissatisfaction with traditional academic art increased, she soon developed a more painterly, coloristic approach, inspired by the new realism of such painters as Edgar Degas and Edouard Manet. At the Salon of 1874, Cassatt's painting *Ida* attracted the attention of Degas, who would become her friend and chief mentor. She was subsequently invited to join the Impressionists (known then as the Independents), and exhibited with them in 1879, 1880, 1881 and 1886.

In addition to her depictions of mothers and children, Cassatt produced numerous images of small girls and boys. Her earliest such compositions were mostly commissioned portraits or more informal portrayals of her various nieces and nephews. However, sometime after 1900, she began a series of portraits of young children, residents of the village near Cassatt's summer home, the Château Beaufresne at Menil-Théribus, Oise. Although she sometimes depicted boys, Cassatt's favorite and most popular subjects were young girls of about five or six years. They included the demure, dark-haired model Margot, the subject of the delicate pencil rendering *Margot's Head*.[1]

Margot, wearing an oversized bonnet, appears in a number of oils, pastels and drawings executed around 1902. In *Margot's Head*, her face appears in three-quarter profile, turned slightly towards the right. While the hair protruding from her hat and her facial features have been rendered in a painterly manner, the rest of her figure and costume appear unfinished, delineated with a fine, quick outline. This approach, in its immediacy and directness, is representative of many of Cassatt's sketches of Margot and other young models.

Margot's Head is more than just a conventional portrait of a little girl. The subject is depicted in adult costume, seemingly poised and grown-up; the portrait anticipates her future as a confident, free-thinking woman. With her unique ability to portray, without sentimentality, children as self-possessed individuals it is not surprising that many critics viewed Cassatt as the preeminent painter of children of her generation.

C.L.

1. *Margot's Head*, listed as no. 873 in Adelyn Breeskin's catalogue raisonné, is also known by the title, *Tête de fillette, chapeau esquissé.* The image reproduced in Breeskin, taken from an older reproduction, shows only the bust-length portion of Margot. The sheet, once folded, actually contains a full-figure rendering of the girl. See Adelyn Dohme Breeskin, *Mary Cassatt: A Catalogue Raisonné of the Oils, Pastels, Watercolors, and Drawings* (Washington, D.C.: Smithsonian Institution Press, 1970), p. 289, no. 873.

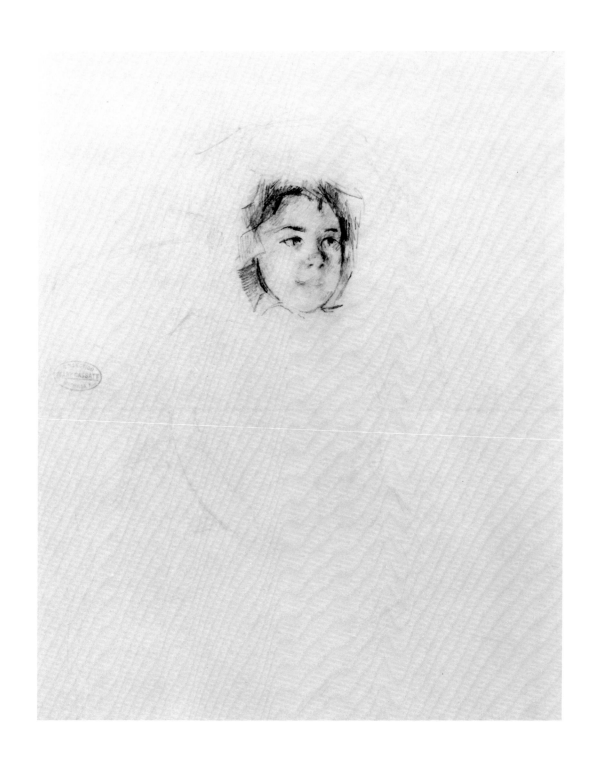

JAMES WELLS CHAMPNEY (1843–1903)

10. *Versailles in Spring*, 1893

Watercolor and pencil on paper

14¾ × 21¼ inches

Signed, dated and inscribed lower left: *J. Wells Champney / Versailles 1893*

Inscribed in pencil on brown paper label affixed to backing: *Garden of Versailles*

PROVENANCE

Private Collection, Connecticut

A NOTED LATE nineteenth century genre specialist, James Wells Champney was one of the earliest American artists to seek European training. After studying under Edward Frère in Ecouen, France, and at the Royal Academy in Antwerp, Champney settled in Boston, where he was active as a painter and illustrator. He later divided his time between Deerfield, Massachusetts and New York City.

Champney worked in oil and watercolor until 1885 when he began to focus almost exclusively on pastel, eventually becoming one of the foremost pastelists of his day. Champney, who had started out as a wood engraver, was also an accomplished draftsman, and he contributed illustrations to many of New York's leading periodicals.

Although he concentrated on pastel after 1885, Champney retained an interest in watercolor through the remainder of his career. From 1875 until his death in 1903, he was a regular contributor to the exhibitions of the American Watercolor Society, of which he was a member. His subject matter ranged from portraits and genre pieces to landscape renderings of such diverse locales as the Bay of Digby in Nova Scotia, the Chamonix Valley in France, and the Pocumtuk Valley of Massachusetts. According to John La Farge, himself an esteemed watercolorist, Champney's watercolors were "very beautiful [and] with such a note of serenity and a quality of truthfulness as to give the time of day, weather, even the very different kind of light in France or England."[1] Certainly, Champney's familiarity with the *plein air* tradition and his ability to convey the effects of natural outdoor light are readily apparent in *Versailles in Spring* of 1893.

In this picture, probably painted during one of his summer trips abroad, Champney has depicted a view of the formal gardens of Versailles under a cool, blue-gray sky. To the left, a young girl and boy stroll along the pavement, next to a portion of the famous gardens, replete with clipped shrubbery, statuary and colorful blossoms. Champney gives this scene a brilliant luminosity by employing broad, transparent washes of fresh colors (primarily green and blue with vivid touches of red, orange and yellow) and allowing only a small portion of the white paper to show through.

In *Versailles in Spring*, Champney combines precise, academic draftsmanship with his interest in light, atmosphere and color; the end result is a work notable for its immediacy, spontaneity and great delicacy.

C.L.

1. John La Farge quoted in *James Wells Champney, 1843–1903*, exh. cat. (Deerfield, Mass.: Hilson Gallery, Deerfield Academy, 1965), p.[39].

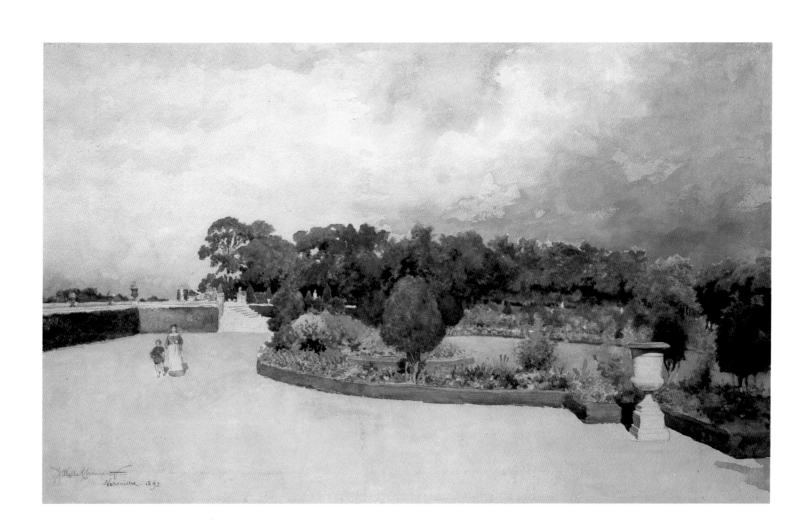

JAMES WELLS CHAMPNEY (1843–1903)

11. *Woman Seated Holding Lilies*, 1902

Pastel on paper
30 × 25 inches
Signed and dated lower right: *J. Wells Champney / 1902*

PROVENANCE
Private Collection, East Coast

D URING THE EARLY 1880s, while a professor of art at Smith
College, James Wells Champney began working in pastel.
According to a later account, his discovery of the medium was
accidental, prompted by a student who "asked him so many questions on
pastels that he experimented and found a success so surprising that he
largely confined his efforts to pastel."[1]

Certainly, Champney's (and his student's) curiosity about pastel was
timely, coinciding as it did with the formation of the Society of Painters in
Pastel in 1882. Founded in New York by such artists as Robert Blum and
William Merritt Chase, the Society held four exhibitions: in 1884, 1888,
1889 and 1890. These served to revive interest in the medium, formerly
considered too impermanent physically and too feminine for serious
artistic pursuits. While many of the early proponents continued to use
pastel throughout their careers, oils remained their primary means of
artistic expression. Champney, by contrast, worked almost exclusively in
pastel after the mid-1880s. By 1897, after a successful exhibition at M.
Knoedler & Company in New York, Champney was heralded as "the best
known painter of pastels in America."[2] For his works after Old Master
paintings and his portaits of refined female types, Champney was
acclaimed by critics, who cited his graceful draftsmanship, his smooth,
satin-like finishes and the delicacy of his color. His approach is well
exemplified in the elegant *Woman Seated Holding Lilies* of 1902.

Champney has here depicted a young, unidentified woman seated in
a stately armchair. Wearing a high-waisted "empire" gown in yellow-gold,
she sits against an unadorned background with one leg crossed, holding a
bouquet of white lilies. Inspired by the eighteenth century pastel
tradition, as represented by such artists as La Tour, Liotard and Rosalba
(whose work he saw in the great galleries and museums during his
numerous trips abroad), Champney combines solid, academic drafts-
manship with rich, warm coloration. By applying his chalks with dense,
measured strokes, at times gently blending tints with his fingertip, he
creates subtle nuances of light and dark as well as soft, smooth surface
effects, not unlike those created with oil. Champney's conception, in its
idealization of form and elegant repose, also brings to mind the British
Romantic tradition of the late eighteenth century.

C.L.

1. "Artist Killed by a Fall," *New York Times*, 2 May 1903, p. 3.
2. "J. Wells Champney's Pastels," *New York Times*, 6 April 1897, p. 9.

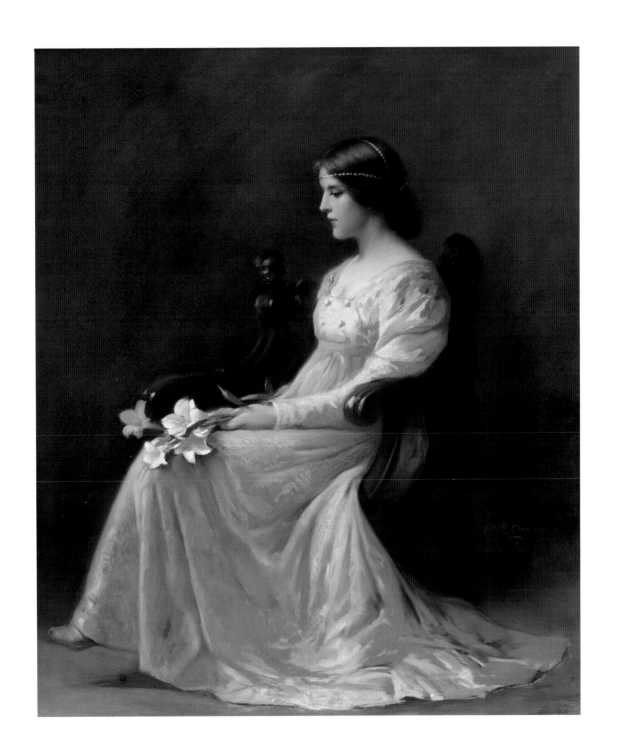

CHARLES CARYL COLEMAN (1840–1928)

12. *Capri Girls Pruning Vines*, 1896

Watercolor, gouache and pencil on paper
14¼ × 21 inches
Signed and dated lower left: *CCC(in monogram)/1896*

PROVENANCE
The Century Company, New York

LITERATURE
Frank D. Millet "Home of the Indolent: The Island of Capri," *Century* 56
(October 1898): 856 (as *Girls Pruning Vines, Town of Capri In the
Distance*, engraved by F. H. Wellington).

WIDELY ACCLAIMED IN America and abroad for his renderings of the landscape and monuments of Italy, Charles Caryl Coleman lived an expatriate lifestyle, spending the majority of his career on the island of Capri. A native of Buffalo, New York, Coleman received his early training from a local painter, William H. Beard, during the late 1850s. This was followed by periods of study in Paris and Florence under Thomas Couture. After serving in the Civil War, Coleman lived in Venice and Rome before moving permanently to Capri in 1884. He subsequently became one of the more prominent members of the colony of American and British artists who had gathered at Capri, drawn to the island's serene beauty. Working in a realist manner, Coleman painted subjects such as Greek and Roman statuary, which he avidly collected, and the sun-filled gardens and arbors that surrounded his home, the "Villa Narcissus." He also produced many views of the eruption of Mount Vesuvius, recording its effects on the light and atmosphere of the region and on the waters of the nearby Bay of Naples.

Like other artists of his circle, Coleman also took the island inhabitants as subjects. His watercolor *Capri Girls Pruning Vines* is representative of both his skill as a watercolorist and his enduring penchant for the exotic. We are presented with a view of three young women pruning fig vines at the edge of a hillside. They wear traditional, indigenous dress: long skirts, shirts and bodices and hair kerchiefs. The town of Capri is visible in the distance.

While the landscape is rendered with broad washes of watercolor and gouache, Coleman uses sharp outlines to define the figures and vines in the foreground and the various architectural elements in the background. The ease and fluidity of his approach, especially his ability to work with transparent washes of paint, inspired one critic, writing for the *American Magazine of Art*, to deem him "one of our foremost American water-colorists."[1]

Capri Girls, along with several other renderings by Coleman featuring peasant women working in the island's fields and vineyards, was reproduced in an article written for *Century* magazine by another American painter who had visited Capri, Francis D. Millet.[2] Entitling his text "The Home of the Indolent," Millet paid tribute to the "enchanting beauties of the scenery" and the "classical perfection" of the peasant population. He went on to lament the "loss of local costume," noting that the conventional mode of dress, as illustrated in Coleman's renderings, was gradually being replaced by "the corset, the shirt-waist, and the latest twist of the hair." Thus, *Capri Girls Pruning Vines* not only testifies to Coleman's abilities as a watercolorist but also serves to document a slowly disappearing way of life.

C.L.

1. "Charles Caryl Coleman," *American Magazine of Art* 15 (September 1924): 466.
2. Frank D. Millet, "Home of the Indolent: The Island of Capri", *Century* 56 (October 1898): 853–856.

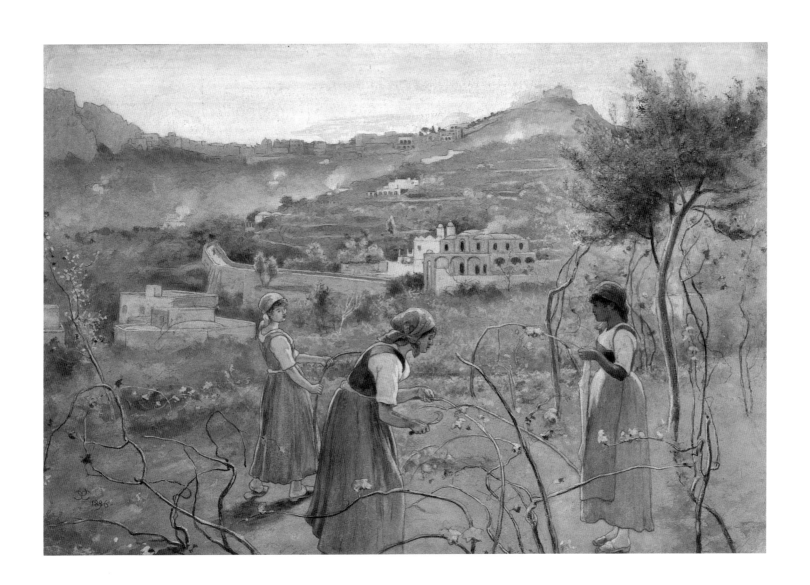

GLENN O. COLEMAN (1887–1932)

13. *Cafe*, ca. 1910

Charcoal, watercolor and gouache on paper
15½ × 20 inches
Signed lower right: *Glenn O. Coleman*

PROVENANCE
Gerritt Benniker
By descent through the family
Private Collection, Seekonk, Massachusetts
Mr. and Mrs. Robert P. Weimann III, Connecticut

AFTER MOVING FROM Springfield, Ohio, to Indianapolis as a young man, Glenn O. Coleman studied there at the Industrial School and worked as an apprentice artist at a newspaper. After another move he received further instruction from Robert Henri at the New York Art School. In New York Coleman lived in impoverished circumstances, yet he presented the city in picturesque terms, capitalizing on the vitality and exotic ambience of downtown neighborhoods. An adherent of the Ashcan School, Coleman was a coordinator, along with Arnold Friedman, of the important 1908 exhibition of works by students of Henri at the Harmonie Club in New York which followed the close of the landmark show of works by the Eight at the Macbeth Gallery. Coleman maintained the dynamic realist style of Henri and others into the 1920s and it was only in the last years of his life that he began to incorporate modernist and cubist devices into his urban scenes.

In *Cafe* Coleman depicts a throng of city dwellers avidly engaged in conversation and activity in a downtown New York tavern. His background as a newspaper artist is evident in his inclusion of descriptive details: a woman has fallen from her chair in the foreground; a man does a high-step kick to the music of the piano player in the background. Paintings on the wall, most including nude figures in unconventional poses, contribute to the lively atmosphere and convey the attitude of permissiveness and bold outrageous fun that the modern city offered. With accentuated curves—the swinging lines of the women's dresses and the circular shapes of broadbanded hats—he captures the locale's spirited mood. The animated application of the media and the limited palette of black and white (with orange and pink accents in the dresses) further convey the dynamic character of the dimly-lit, somewhat squalid environment. *Cafe* reflects Coleman's adherence to the attitude of the

Ashcan School, an opposition to academic styles and genteel subjects, and a preference for truth over beauty, real life over abstract aesthetic concerns.

L.P.

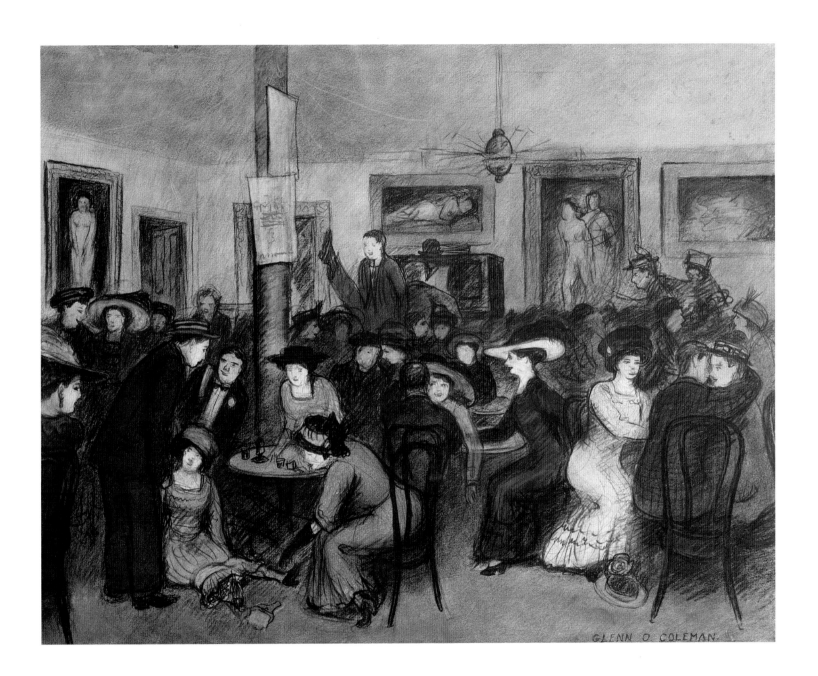

FELIX OCTAVIUS CARR DARLEY (1822–1888)

14. *Our Guide Louis Gill, Flat Boatman*, 1859

Pencil and watercolor on green toned paper

13⅞ × 9¾ inches

Dated and inscribed lower left: *Louis Gill/July 8th 1859*

Inscribed on the reverse: *Sketch of our Guide/Louis Gill/Moosehead
 Lake/Maine 1859*

PROVENANCE

Lewis C. Gratz, Philadelphia, Pennsylvania

[Freeman's, Philadelphia, 22–23 January 1909, lot 532]

The Carl and Lily Pforzheimer Foundation, Inc.

IN 1859 FELIX OCTAVIUS CARR DARLEY, at the peak of his career, was preparing to marry and move to a new home on the shores of the Delaware River, in Claymont, Delaware. The drawing *Our Guide Louis Gill, Flat Boatman* was undoubtedly executed that year during a summer escape from New York City to Moosehead Lake, in the northern reaches of Maine.

With portraitlike accuracy, Darley captures the lined features of his guide, who peers ahead in concentration while skillfully maintaining control of the boat. Darley reinforces the sense of mastery through his pyramidal composition, with the figure solidly placed in the center. The drawing's triangular configuration and subject, moreover, suggest a comparison with contemporary paintings of George Caleb Bingham. Darley would certainly have been familiar with Bingham's work, as several of the latter's works, including *Fur Traders Descending the Missouri* (1845; Metropolitan Museum of Art, New York) and *The Jolly Flatboatmen* (1846; Manoogian Collection, Detroit, Michigan), were purchased by the American Art Union, and engravings were distributed by lottery during the years 1845–1850. Darley began an association with the Union during this time, in 1849, when he was commissioned to produce drawings for the Union's edition of two of Washington Irving's short stories, *Rip Van Winkle* and *The Legend of Sleepy Hollow.*

During his lifetime, Darley's drawings attracted the attention and praise of numerous critics, among them Henry T. Tuckerman, who appreciated especially his ability to render native subjects:

> Darley has made a study of American subjects, and finds therein a remarkable range from the beautiful to the grotesque, as is manifest when his drawings are compared; it is rare for the same hand to deal so aptly with the graceful and the pensive, so vigorously with the characteristic and so broadly with the humorous; and exhibit an equal facility and felicity in true, literal transcript, and in fanciful conception.[1]

This drawing, with its rugged rendering of a guide from the Maine frontier, stands as an example of Darley's national imagery at its best.

B.B.

1. Henry T. Tuckerman, *Book of the Artists*, reprint. New York: James F. Carr, 1967, p. 475.

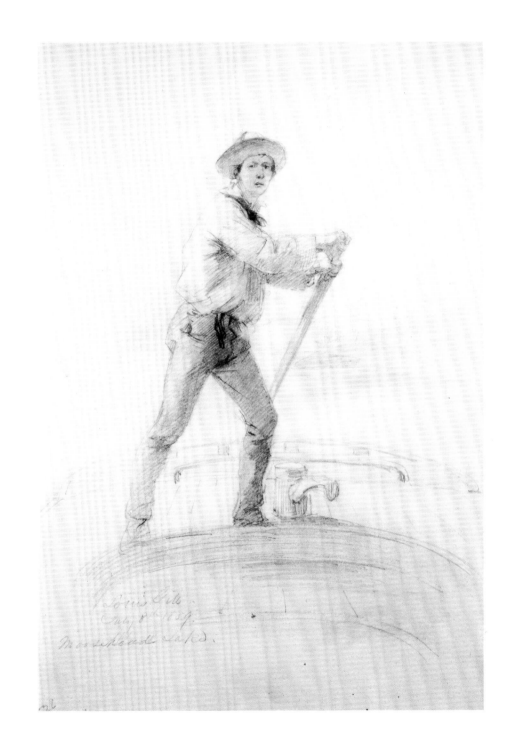

Louis Gill
July 6th 1859
Moosehead Lake.

JAMES HENRY DAUGHERTY (1887–1974)

15. *Abstraction*, 1968

Pastel on paper
16¾ × 14 inches
Signed with initials lower right: *JD*
Dated lower left: *June 12/68*

PROVENANCE
The artist's son, Connecticut
[Connecticut Fine Arts, Westport, Conneticut]
[The Uptown Gallery, New York, ca. 1979]
Private Collection, New York

JAMES HENRY DAUGHERTY was born in Ashville, North
Carolina, and raised in the Midwest. When his family moved to
Washington, D.C., he attended the Corcoran School of Art. He later
studied with William Merritt Chase at the Pennsylvania Academy of
the Fine Arts. Although he traveled to Europe from 1905 to 1907, much
of the time was spent in London studying with Frank Brangwyn, a
muralist and an aesthetic conservative. Daugherty was thus isolated from
the artistic revolutions then occurring in Paris. He did not catch the spirit
of modernism until he saw the Armory Show in New York in 1913, which
moved him so strongly that he would base his coming work on Cubist
and Futurist practice.

European avant-garde movements appeared in rapid succession early
in the century, but Synchromism, conceived in Paris in 1913 by Morgan
Russell and Stanton MacDonald Wright, became the first American
modernist style. Using abstract shapes of solid color to convey mass and
solidity, Daugherty, who learned Synchromist principles and techniques
through his friend Arthur B. Frost, Jr., soon became one of the
movement's major exponents. His monumental color abstractions painted
from 1915 to 1922 contributed to the viability of the style.

Abstraction, a pastel drawing of bright broken arcs and triangular
wedges enhanced by variegated color, is a very fine example of
Daugherty's late Synchromist work. Experiencing a new burst of creative
power during his seventies and early eighties, Daugherty devoted an
intense effort to the recreation of the spirit of early Synchromism. In this
arrangement, pure primary colors recede, pull forward or lie flush with
the picture plane, their staccato rhythms and tensions fractured further
by the intruding white paper. Daugherty's fields of brilliant abstract color
evoke a sense of the sculptural third dimension, achieving precisely what
the Synchromist founders and the youthful Daugherty had desired.

A.J.P.

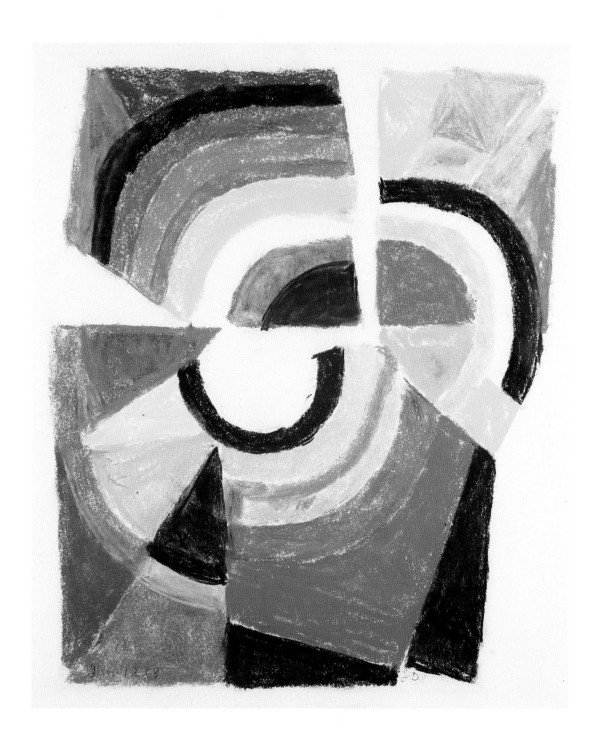

RANDALL DAVEY (1887–1964)

16. *Horse in a Landscape*, ca. 1920s–1930s

Watercolor, pen and ink and pencil on paper
17½ × 20⅛ inches
Signed lower right: *Randall Davey*

PROVENANCE
Private Collection, East Coast, United States

RANDALL DAVEY was a painter, muralist and teacher as well as a prominent member of the art colony at Santa Fe, New Mexico. Born in East Orange, New Jersey, Davey studied architecture at Cornell University from 1905 until 1907. In 1908 he moved to New York City to study art. After a brief period of instruction at the Art Students League, Davey transferred to the New York School of Art, where he became a disciple of Robert Henri. In 1910 he accompanied his teacher to Europe, where he studied Old Master paintings in the major museums and galleries. During the ensuing years, Davey participated in many important exhibitions in New York, including the Armory Show of 1913.

In 1919, while visiting Santa Fe with the artist John Sloan, Davey became so enchanted with the beauty of the landscape that he decided to move there permanently. A year later he acquired an old saw mill on the outskirts of town, which he converted into a studio. Davey's New York background and cosmopolitan outlook served to enliven Santa Fe's cultural milieu; he quickly became well known among local artists.

Davey's early work, dark and broadly painted, reveals the influence of Henri. His move to the Southwest, however, had liberating effects. Freed from what he referred to as "the political manipulations in the art world back East," Davey adopted a simpler and more subjective vision of nature.[1] Inspired by the tenets of European Post-Impressionism, he began to put a greater emphasis on color and design. He also started working in media other than oil, notably watercolor and etching.

Davey explored such themes as still life, the nude and the portrait. A skilled equestrian, he also liked to paint horses and horse racing events, as well as indigenous animals such as bulls and burros. In his *Horse in a Landscape*, Davey's forms are abstracted from nature. They appear weightless and two-dimensional, painted in delicate, transparent washes of yellow, blue, pink and green, applied arbitrarily. Linear accents on the desert foliage and on the mane and tail of the horse are combined with soft masses of pure color in the sky, water and on the steep walls of the canyon, thus providing a lively textural variation. Davey's approach, involving an exploration of the rhythms of color, line and pattern, results in a fresh, lyrical and very modern interpretation of nature.

C.L.

1. Randall Davey quoted in John Sloan, "Randall Davey," *New Mexico Quarterly* 21 (Spring 1951): 25.

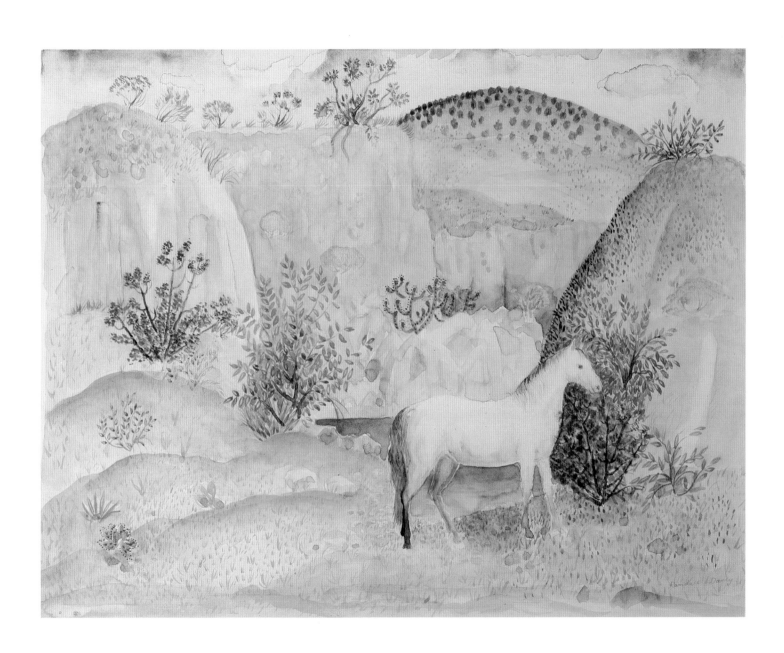

RAOUL MAUCHERAT DE LONGPRÉ, FILS (B. 1859)

17. *Cut Roses and Lilacs with Shears*, ca. 1890s

Gouache and pastel on paper laid down on board
28⅞ × 37 inches
Signed lower right: *Raoul M. de Longpré fils*

PROVENANCE
Private Collection, New York

THE FRENCH-BORN PAINTER known as Raoul M. de Longpré, fils, recognized for having devoted a lifetime to the scientific and artistic study of flowers, began his artistic training in Lyon. He arrived in Paris in 1877, where he continued his earlier botanical and artistic studies while living with a close relative, Paul de Longpré, also an artist and a major figure in the genre of flower painting. Raoul de Longpré began to exhibit at the Paris Salon almost immediately after settling in the city, and by the 1880s his paintings were finding buyers in the United States. Today, examples are held by the National Museum of American Art in Washington, D.C. and by many public and private collections.

In *Cut Roses and Lilacs with Shears* we have an element unusual in de Longpré's work; since he ordinarily focused his attention almost entirely on the flowers themselves, the depiction of the pair of shears here is rare. The shears are undoubtedly included to indicate the freshness of the newly cut blossoms, which are strewn on their support as if just brought from the garden. The painting also displays conversance with nineteenth century "language of flowers" lore and literature, in which roses and lilacs (de Longpré's favorite flower), depicted together, commonly symbolize youthfulness and first love.

B.J.M.

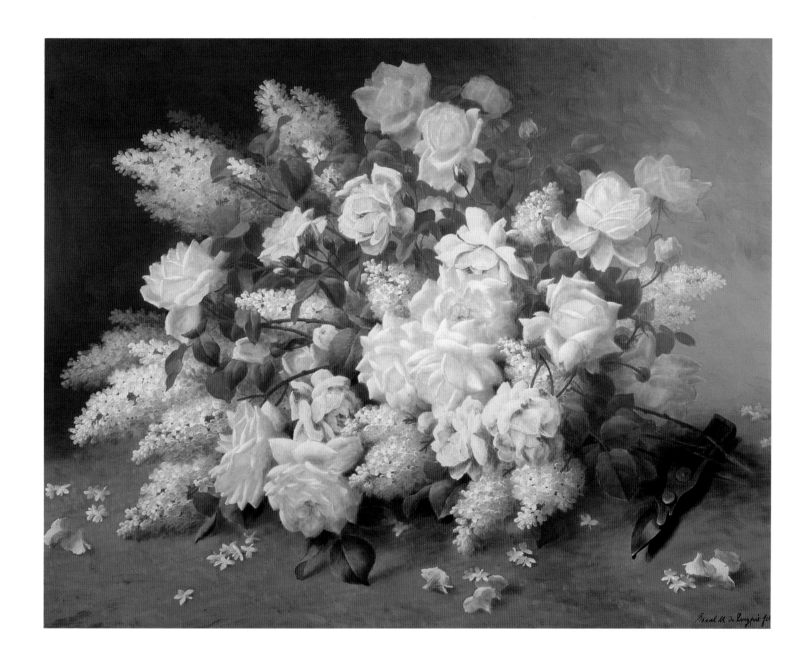

PERCIVAL DE LUCE (1847–1914)

18. *Springtime Reverie*, ca. 1890s

Watercolor and gouache on paper
17 × 14 inches
Signed lower right: *Percival De Luce*

PROVENANCE
Private Collection, New York

A RESIDENT OF New York City for most of his life, Percival De
Luce enrolled at the National Academy of Design in 1864 (he
became an Associate in 1897). In the 1870s he furthered his
education in Europe, studying with Jean François Portaels in Brussels and
Léon Bonnat in Paris. De Luce was a member of the American
Watercolor Society, an organization to which he frequently contributed
works.

In *Springtime Reverie* De Luce conveys the lure of rural nature to
urbanites of the turn-of-the-century. The landscape, rendered with fluid
brushwork and softly blended colors, appears lush and verdant. Seated in
its midst, a young woman gazes into the distance. The freshly picked
bouquet in her hand provides a bright contrast to her practical walking
suit of gray muslin. Treating a theme that preoccupied artists in the
nineteenth century, De Luce presents nature as a stimulus to contempla-
tion and a release from the pressures of modern life.

L.P.

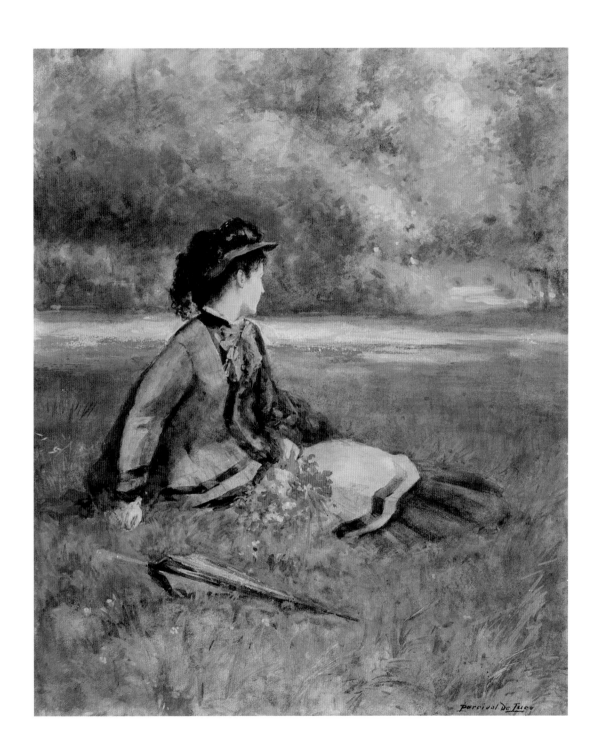

Perrival De Luce

THOMAS WILMER DEWING (1851–1938)

19. *Girl Playing the Lute*, ca. 1910

Pastel on light brown paper

10½ × 7 inches

Signed lower right in pencil: *T W Dewing/9*

PROVENANCE

The artist

Hugo Reisinger, New York, ca. 1910–1914

Estate of Hugo Reisinger, 1914–1916

[Sale, American Art Galleries, New York, "The Valuable Pictures by
 Foreign and American Masters Collected by the Late Hugo
 Reisinger", 18 January 1916, lot no. 2]

Mrs. Hugh Murray

[Art market, possibly Cincinnati, Ohio, ca. 1950's]

Private Collection, Cincinnati, Ohio, 1950's–1989

LITERATURE

"Reisinger Picture Sale," *American Art News*, vol. 14, November 27, 1916,
 p. 2

*Illustrated Catalogue of The Valuable Pictures by Foreign and American
 Masters Collected by the Late Hugo Reisinger* (New York: American
 Art Galleries, 1916), Lot No. 2

"The Hugo Reisinger Sale," *American Art News*, vol. 14, January 22, 1916,
 p. 2

Florence N. Levy, ed., "Paintings Sold At Auction: Season of 1915–1916,"
 American Art Annual, vol. 13 (Washington, D.C.: The American
 Federation of Arts, 1916), p. 346

THOMAS DEWING was born in Boston and attended the School
of the Museum of Fine Arts there. He developed a proficiency in
pastel early and drew portraits in that medium in order to finance
a three-year trip to Paris (1876–1879) where he studied with Jules
Lefebvre and Gustave Boulanger. He also worked with Frank Duveneck
in Munich during this period.

After his studies abroad, Dewing took a studio in Boston for two
years but then settled in New York City, where he taught at the Art
Students League until 1888. He became the protégé of the well-known
architect Stanford White, who later often designed Dewing's frames. It
was White who brought the artist's work to the attention of a number of
important patrons, among whom were Charles Lang Freer of Detroit and
John Gellatly of New York.

By the mid-1880s, Dewing had begun to pursue his own vision,
which evolved into one of the most sensitive and poetic sensibilities in late
nineteenth century figure painting.

Compositionally, *Girl Playing the Lute* derives from Dewing's great
interest in the works of Jan Vermeer. The seventeenth century Dutch
painter inspired the musical themes for which Dewing became known
during the 1890s. The American artist would have seen Vermeer's
paintings when he was in London and Paris in 1894. Closest to the
composition considered here is *Lady Playing a Guitar*, which Dewing saw
when he and his patron Charles Lang Freer traveled together in January
1906 to see the John G. Johnson Collection in Philadelphia.[1] In 1906 and
1907 Freer also sent the artist the three volume study on Vermeer by the
Dutch historian C. Hofstede de Groot.[2] At about this point Dewing's
interest in Vermeer inspired a series of oil paintings in which his sitter is
seen in profile with her back to the viewer.[3] As in these paintings, *Girl
Playing the Lute* focuses on the shoulders and back of the sitter, giving
less emphasis to other portions of the composition, such as the bench or
the soft, filmy dress.

In about 1910 Dewing began employing a more sketchlike style than
he had used previously in his pastels, this quality is evident in *Girl Playing
the Lute*, where he freely renders the bench and gown of the sitter. The
focus is on important aspects of the composition, such as the sitter's
profile. The artist's ability in a difficult medium is especially demonstrated
here, in the lovely face. Rather than a conventional, linear execution of
the profile, Dewing deftly brings the pastel crayon up to the nose, mouth
and chin, stopping only when he has achieved the subtle nuances
intended. Attention is also paid the sitter's auburn hair, for which Dewing
employs hues ranging from a bright red-orange to soft brown, delicate
russet and yellow. As he did in his oils, he then tones these bright colors
with cool blues and grays. The result is a beautiful and complex web of
colors.

S.H.

1. Charles Lang Freer to Thomas Dewing, 13 January 1906, vol. 19, Charles
Lang Freer Papers, Library, Freer Gallery of Art, Smithsonian Institution,
Washington, D.C.
2. Charles Lang Freer to Thomas Dewing, 29 April 1907, vol. 22, Freer Papers.
Freer probably sent Dewing the three volume work, *Jan Vermeer von Delft und
Karl Fabritus* (Leipzig, Hiersemann, 1905).
3. Good examples of such paintings are *The Yellow Tulips* and *The Mirror*, both in
the Freer Gallery of Art, Smithsonian Institution, Washington, D.C.

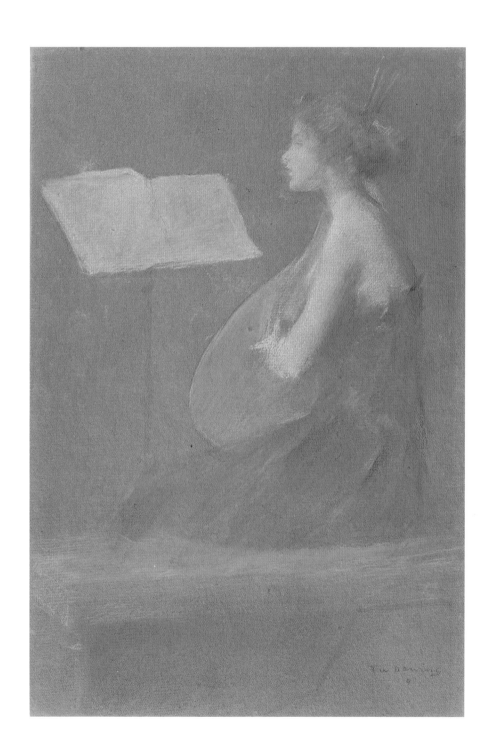

CHARLES WARREN EATON (1857–1937)

20. *Group of Pines*, ca. 1910s–1920s

Watercolor on paper
11¼ × 15¼ inches
Signed lower right: *Chas Warren Eaton.*

PROVENANCE
Private Collection, Philadelphia

CHARLES WARREN EATON was trained at the National Academy of Design and at the Art Students League, both in New York. During the mid-1880s, he visited France, England and Holland, familiarizing himself with the art of the Barbizon School. Eaton was a major figure of the American Tonalist movement, drawing widespread acclaim for his quiet, suggestive renderings of the snow-covered fields in and around Bloomfield, New Jersey, and his serene depictions of the pine forests of New England. Although Eaton usually painted in oil, he was also an enthusiastic watercolorist who exhibited at the annual exhibitions of the American Watercolor Society and the New York Watercolor Club. Today, only a small portion of his work in this medium is extant.

Although Eaton's mature work also included landscape views of Bruges, Belgium and Lake Como, Italy, his thematic preference for his native lanscape earned him the epithet "The Pine Tree Painter." His wistful depictions of lush, wooded areas of New England, usually painted in the vicinity of his summer studio in Thompson, Connecticut, well reflect his choice of place: "I seek the quietest possible places . . . even a cow disturbs me."[1]

Group of Pines portrays a verdant summer landscape dominated on the left by a group of tall, stately pine trees. It is characterized chromatically by soft, overlapping washes of translucent greens and blues. Eaton's technical approach, involving broad, loose brushwork and the elimination of detail, heightens the poetic mood.

Group of Pines represents Eaton's very subjective and visionary response to native scenery. Taking his aesthetic cue from his friend and mentor George Inness, whose late work shows a similarly evocative treatment of landscape, Eaton sought to convey the "essence" or "spiritual truth" behind nature. This attitude, as well as the notion that nature could be a vehicle for transporting the soul to a higher, more ideal state, was shared not only by Eaton and Inness, but by such of their contemporaries as Henry Ward Ranger, Dwight Tryon and other artists associated with American Tonalism.

C.L.

1. Charles Warren Eaton quoted in Lolita L.W. Flockhart, "Charles Warren Eaton," *New Jersey Club Woman* 9 (February 1935).

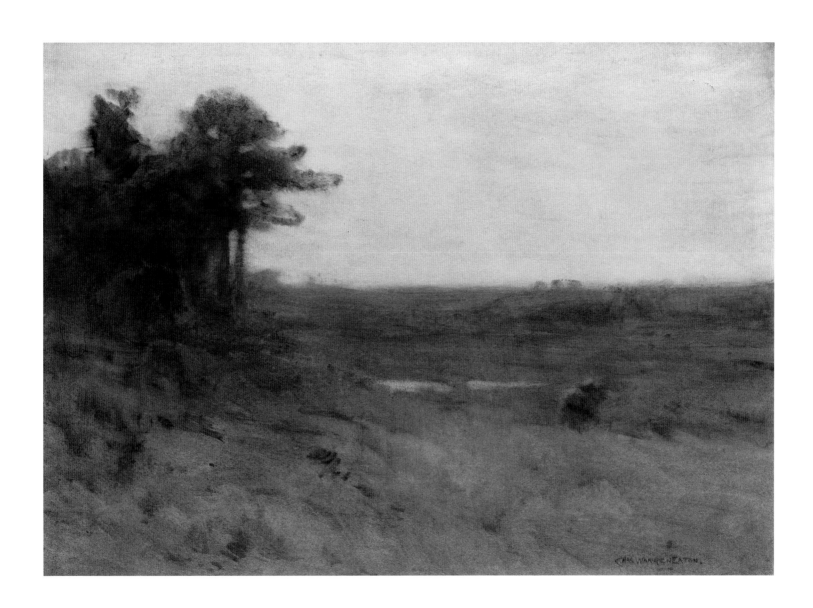

CHARLES HENRY FROMUTH (1861–1937)

21. *Grey Evening in October*, 1901

Pastel on paper laid down on board
Signed, dated and stamped with the artist's insignia lower left: *Ch
Fromuth 1901/ Oct 31–1901*
Inscribed verso: *A Grey Evening in October/ Ch Fromuth—Concarneau
1901*

PROVENANCE
By descent in the artist's family

CHARLES FROMUTH was born in Philadelphia. He was a pupil
of Thomas Eakins at the Pennsylvania Academy of the Fine Arts
for five years and was the prosector—the student who did
dissections—for Eakins in his anatomy classes.

Fromuth had earned enough from his textile designs and model
building to make a trip to France in 1889, where he studied briefly under
William-Adolphe Bouguereau and Tony Robert-Fleury at the Académie
Julian. His fellow students Robert Henri and Edward Redfield told him of
the picturesque villages along the Normandy coast, and in July of 1890 he
left Paris with the intention of visiting Pont Avon and Concarneau. He
stayed on, a permanent resident of Concarneau for forty years, and he
died there in 1937.

Fromuth's *Grey Evening in October* shows the distinctive red sails,
weathered to a rich variety of hues, of the Concarneau sardine fleet.
Hundreds of these deckless crafts sailed in and out of the village's
crowded harbor every day. Here they are shown in port, with sails furled
and indigo nets festooned from the masts to dry. The moored and
beached boats and the collective activity of their crews are seen from the
high vantage point of the quay, affording Fromuth the "Japanese"
perspective and surface pattern he favored.

Working rapidly in pastel, in the open air, he recorded with
expressive freshness the direct impression of a thoroughly familiar motif,
capturing fleeting moments of motion and reflected light with deft
touches of pure color. In this he shows the influence of Impressionism.
Fromuth scales his palette to the subtle tonalities of the evening hour. The
composition recalls the Japonism of the Nabis and Art Nouveau. In *Grey
Evening in October* we see why Fromuth's original synthesis of modern
movements had earned him wide recognition abroad and admiration
among American artists.

D.S.

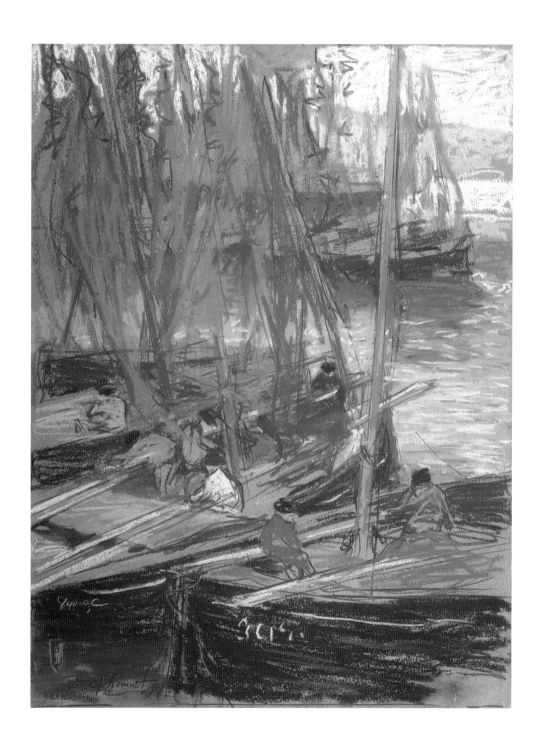

HENDRIK GLINTENKAMP (1887–1946)

22. *The Man with the Skis*, 1915

Watercolor on paper
11 × 15 inches
Signed lower left: *Glintenkamp*
Signed again upper right verso: *Glintenkamp*
Inscribed with title and date verso: *The Man with the Skis 1915 B-74*

PROVENANCE
Estate of Fred Babbish

HENDRIK GLINTENKAMP was born in Augusta, New Jersey. A painter, printmaker, draftsman and editor, he was part of an artistic circle that included such influential figures as Robert Henri and John Sloan, both of whom were his teachers. Early in his career, Glintenkamp shared studio space with his friends and fellow artists, Stuart Davis and Glenn O. Coleman. The trio shared a commitment to Henri's realism and the portrayal of urban life. However, as with many of his contemporaries, Glintenkamp's aesthetic underwent a major transformation after his exposure to the Armory Show of 1913.

Organized in New York by a group of pioneering artists that included Walt Kuhn and Arthur B. Davies, the Armory Show served as a catalyst for the development of American modernism. For many artists, as well as for the general public, this was a first opportunity to view the work of the European vanguard, including Henri Matisse, Vincent Van Gogh and Marcel Duchamp. Glintenkamp was among the younger generation of Americans exhibiting in the show. Like Stuart Davis, who recalled the Armory Show as "the greatest single influence I have ever experienced," Glintenkamp was very receptive to the more progressive art on display and quickly assimilated the new ideas into his own work. Only two years later, Glintenkamp produced the watercolor *The Man with the Skis*, painted in a radically different style than the representational realism he had developed under the tutelage of Robert Henri.

Although Glintenkamp has provided us with a descriptive title, what we see before us bears little resemblance to natural representation. Indeed, the real subjects of this picture are color, line and form, all of which have been arranged on the surface according to the artist's inner sensibilities. Glintenkamp presents us with a lively, expressive combination of arcs, curves and lines rendered in an array of bright hues. Conventional perspective is ignored in favor of an enigmatic space,

limitless in all directions. The overall spontaneity, the creative use of color, and the expressive distortion of form are reminiscent of Kandinsky's early "Improvisations," which paved the way for the development of non-representational art within the Western tradition. Glintenkamp surely saw the Kandinsky on display at the Armory Show, *Improvisation No. 27* (1912; Metropolitan Museum of Art, New York), in which descriptive naturalism is forfeited in favor of a spontaneous manipulation of color and shape reflective of the artist's spiritual responses to nature. Glintenkamp has taken a similar route, communicating his vigorous and energetic reaction to his subject through purely formal means.

C.L.

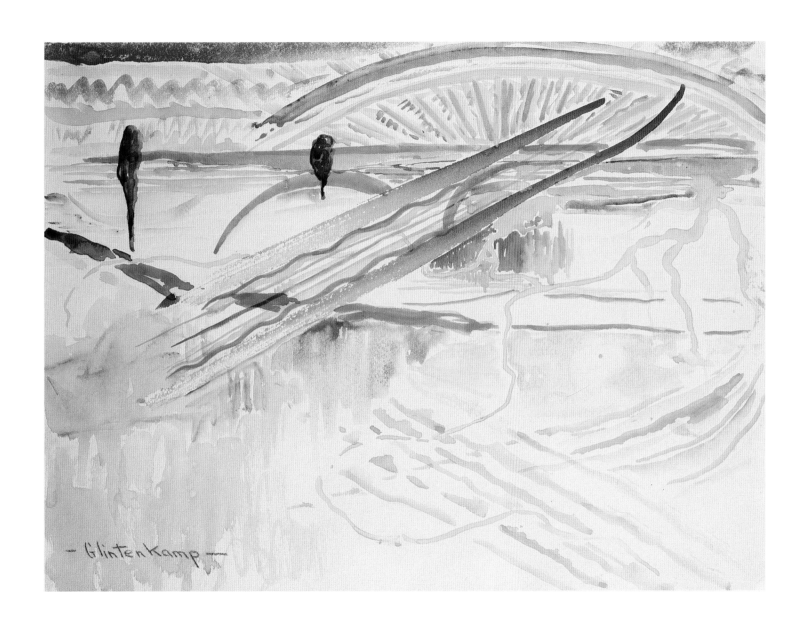

- Glintenkamp -

ARTHUR CLIFTON GOODWIN (1866–1929)

23. *Full Summer, Boston Public Garden*, ca. 1920

Pastel on board

17⅞ × 21⅞ inches

Signed lower right: *A.C. Goodwin*

PROVENANCE

Private Collection, Cambridge, Massachusetts

BORN IN PORTSMOUTH, New Hampshire, Arthur Clifton Goodwin grew up in Chelsea, Massachusetts, and began his career in Boston in the early 1900s. He was self-taught as an artist and was one of the most gifted and daring of the American Impressionists. Goodwin lived in Boston until 1920, and he became well known for his representations of the city. He succeeded in capturing in both oils and pastels the city's charm and graceful dignity. He chose mostly public settings—the city's parks, streets, squares and bridges.

Full Summer, Boston Public Garden is one of his best pastels. A view of a corner of the lagoon in the Boston Public Garden, showing Beacon Street and the distinctive gold-leaf dome of the State House in the background, reveals how he saw the world through impassioned eyes. The high key colors, the way in which the greens are set off by the touches of pink, red and white, produce a brilliant image with a magical after-glow. Black chalk is used in a sophisticated manner to add imaginative depth, bringing a mysterious, shadowy substance to the dreamlike picture.

Though Goodwin never visited France (he died just before he was to have made his first trip) he was very much related, in temperament and approach, to French Impressionism. His work can be compared to that of Maurice Utrillo, the great painter of the city of Paris and leading figure among the second generation French Impressionists. They shared a love of rich color and a bold and lyrical style to convey the soul of their beloved cities.

R.C.

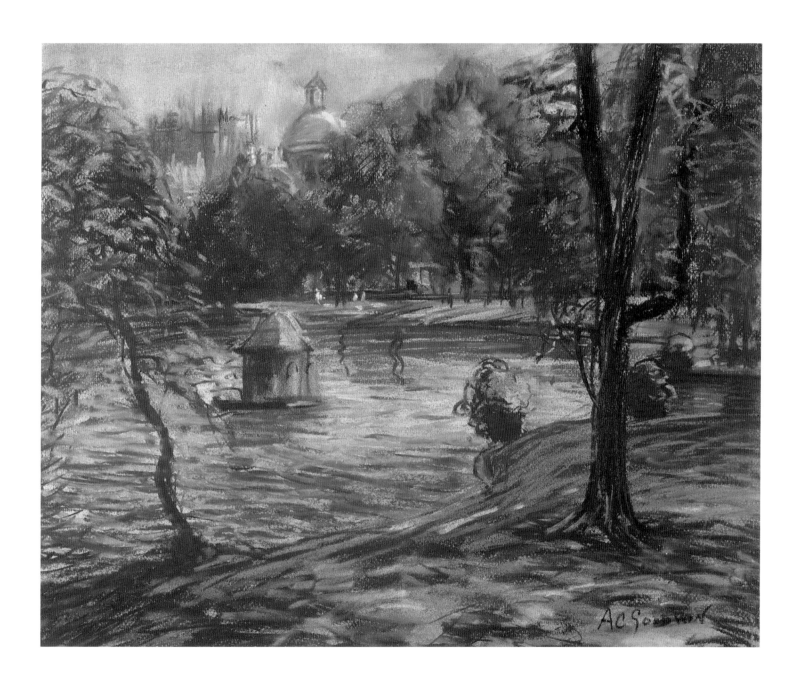

ARSHILE GORKY (1904–1948)

24. *Abstract Figure*, 1931

Pen and ink on paper

12⅝ × 9¼ inches

PROVENANCE

Acquired from the artist

Private Collection, New York

A SHEET FROM a 1931 sketchbook, *Abstract Figure* represents a major phase in the career of Arshile Gorky, one of the truly monumental figures in twentieth century American art, the painter whose pioneering vision helped to determine the development of the New York School and without whom the movement of Abstract Expressionism would be unthinkable.

Abstract Figure is the inspired product of the careful study of Picasso that was undertaken by Gorky in the 1930s. At the time it was done, in 1931, Gorky was living in New York and although he was only twenty-seven years old he already had taught at the New School and Grand Central School of Art. Gorky was becoming known for his fervent championship of modern European art and was at the center of a circle of artists and critics that included the young Willem de Kooning, Stuart Davis and John Graham. For Gorky, Picasso was the quintessential modern artist, bold and daring, willing to defy conventions and break new ground. While this is much the general view of Picasso held today, it was hardly shared by the vast majority of American artists involved then with realism.

Gorky's advanced thinking is reflected in this drawing showing the influence of Picasso's Cubism and the further explication of the Cubist aesthetic that Picasso himself provided in the psychologically charged depictions of women from the middle and late 1920s.

In *Abstract Figure*, Gorky is quoting from the inventive rearrangements of anatomical details found in such Picasso examples as the paintings *Painter and Model* (1928; Museum of Modern Art, New York) and *Nude in an Armchair* (1929; Musée Picasso, Paris). This can be seen in the head for which Gorky—after Picasso—has substituted a triangular shape with a pair of button-holes for eyes, shaded on the side to suggest hair. It is a motif loaded with sexual overtones, as Picasso was wont to do; Gorky has exaggerated other sexual attributes. He has treated the breasts as weighty, pendulous forms, and has moved, in Cubist fashion, the pelvic area to the right hip, its structure distended and shown from above.

From Picasso, Gorky has learned to defy the usual notions of inside and outside. The figure is dressed in a gown, though she is nude in strategic parts and is wearing some of her internal organs on her surface. Like Picasso, Gorky will marry form and imagination with incredibly evocative results. *Abstract Figure* is an early success revealing the eloquent disposition of Gorky's poetic temperament. Not only does this work look forward to the fantastic imagery found in Gorky's late paintings like *The Betrothal II* (1947; Whitney Museum of American Art, New York) but it can also be considered one of the direct American ancestors of de Kooning's great Woman series.

R.C.

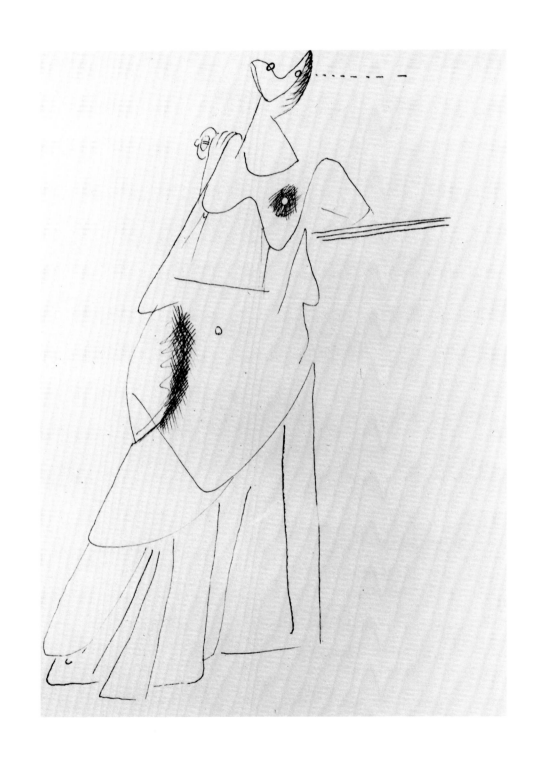

DWINELL GRANT (B. 1912)

25. *Contrathemis III*, 1941

Colored pencil on paper
8½ × 11 inches
Signed with initials and dated lower left: *DG 41*

PROVENANCE
The artist
Private Collection, New York

FROM 1940 TO 1942 Dwinell Grant was employed as an assistant to director Hilla Rebay at the Museum of Non-Objective Painting, now the Guggenheim Museum. In those years the Museum of Non-Objective Painting, through its exhibitions and its program of scholarships and grants channeled through the Guggenheim Foundation, served as a bastion of support for American artists working in a non-objective mode. As the term itself implies, and as it was used by Rebay, a non-objective artist is one who has left the object behind (meaning all vestiges of the world of appearances) while an abstract artist might still make direct references to nature. Grant's drawings and paintings, with their precise structures and sensitively rendered surfaces, were among Rebay's favorites, and the Guggenheim Collection contains a number of these from the late 1930s and early 1940s.

Contrathemis III is a frame from Grant's animated movie of the same title. Running about four minutes, the movie offers a rich perceptual experience of color and form. Each frame reproduces a drawing of the dynamic type illustrated here in which emphasis is placed on relationships between the various geometric elements. Although the drawings used to make the movie were done with this cinematic purpose in mind, they easily stand alone as independent works. The strength and integrity of their composition demonstrates Grant's powers of pictorial construction.

According to Grant, who is still active as an artist and a film maker, with the film *Contrathemis* he was "trying to turn abstract painting into something similar to music by adding motion."[1] The *Contrathemis* film has only recently begun to get the kind of general recognition it has long held among specialists—as one of the genuine creative masterpieces to come out of the American non-objective art movement.

R.C.

1. Interview with the artist, August 14, 1989.

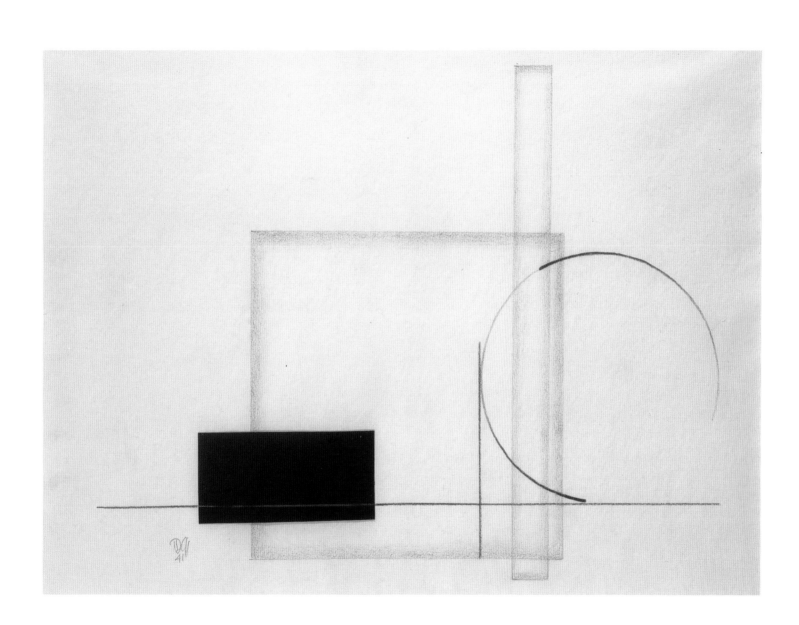

GORDON GRANT (1875–1962)

26. *Misty Morning, Gloucester*, ca. 1930

Watercolor on paper
11 × 14 inches
Signed lower right: *Gordon Grant*
Signed and inscribed with title on an original backing

PROVENANCE
Estate of Jean Klebe, Bristol, Maine

BORN IN SAN FRANCISCO, Gordon Grant sailed to Scotland at the age of thirteen on the clipper *City of Madras* to complete his schooling. This voyage was his initiation into the world of old sailing ships, and he learned about winds, navigation and nautical history during the voyage. At eighteen he was on his way to Glasgow to apprentice for a large ship-building firm when he was dissuaded from this by an art critic, who, having seen his drawings, persuaded him to attend art school in London. During the Boer War, Grant was sent to Africa as a field artist for *Harper's Weekly*. He also worked as an illustrator for *Puck*, the San Francisco *Examiner* and the New York *Sunday World*. He regularly exhibited at Grand Central Art Galleries and Jacques Seligmann & Co. galleries in New York, while spending much of his creative time on the New England coast between Gloucester and Maine.

Like Winslow Homer, Gordon Grant had a deep love of the sea as well as an intense interest in human psychology. *Misty Morning, Gloucester* is a picture that tells an honest story of fishermen and their daily routine, while at the same time it romanticizes their occupation as a noble and pure one. Grant would have envied these sailors their work, their daily exposure to the rigors of the ocean, their expansive environment of eternally beautiful sea. With a few deft strokes he manages to convey both the mystery of the ceaseless, ever-changing water and the elation he derives from his proximity to it. While Grant's subject is realistic, the final effect is imaginative, derived from his own impressions of time spent at sea. As *Herald Tribune* critic Royal Cortissoz wrote in his 1934 review of an exhibition of Grant's watercolors at the Grand Central Art Galleries, it is "the work of a man at home with his theme and in full, easy command of his means of expression."[1] *Misty Morning, Gloucester* is a vivid impression of a lost age, sensitively wrought by an artist who shared the sailor's love of the sea.

N.E.G.

1. Quoted in *Art Digest*, Vol. IX, No. 3, 1 November 1934.

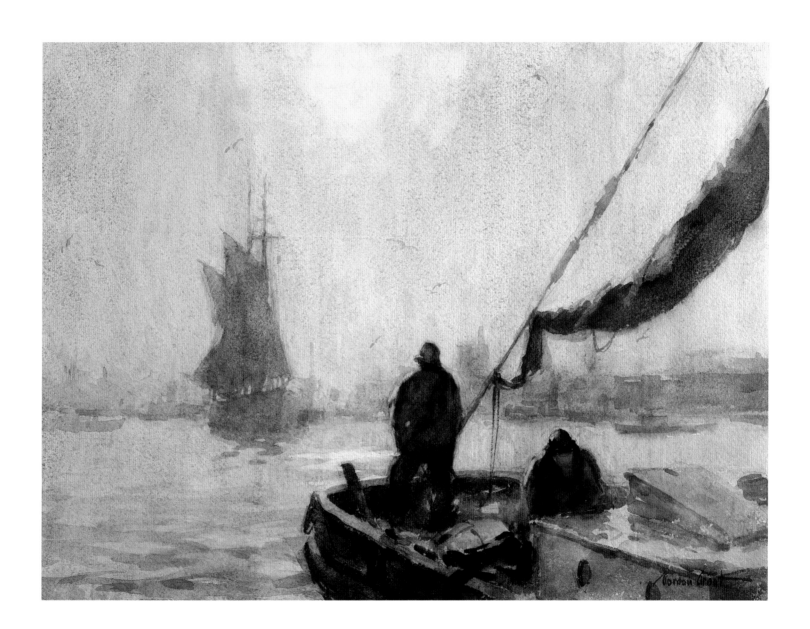

RED GROOMS (B. 1937)

27. *I Nailed Wooden Suns to Wooden Skies*, 1972

Synthetic polymer and collage on paper
21½ × 31 inches
Signed and dated lower right: *Red Grooms/1972*

PROVENANCE
[John Bernard Myers Gallery, San Francisco, California, by 1973]
Private Collection, New York

EXHIBITED
Whitney Museum of American Art, New York, *Extraordinary Realists*, 16
 October–12 December 1973, p. 40 (illus.), as synthetic polymer on
 paper, with John Bernard Myers Gallery, San Francisco.

BORN IN NASHVILLE, Tennessee, Red Grooms attended the
School of the Art Institute of Chicago; George Peabody College
for Teachers, Nashville; and the New School for Social Research,
New York; as well as the Hans Hoffman School of Fine Arts,
Provincetown, Massachusetts. He settled in New York in 1957. The
following year he had his first solo exhibition at the Sun Gallery in
Provincetown. He was awarded several grants, including the Ingram
Merrill Foundation, the American Academy and Institute of Arts and
Letters, and the CAPS grant award for film. Numerous one-person and
group exhibitions have been held at museums and galleries interna-
tionally, including *Red Grooms: A Retrospective 1956–1984*, organized by
the Pennsylvania Academy of the Fine Arts in 1985.

Red Grooms' *I Nailed Wooden Suns to Wooden Skies* typifies the
exuberance and the audacity with which the artist approaches all of his
subjects. In the late sixties and early seventies Grooms was pursuing an
interest in animation, and by 1972 had completed three half hour films. *I
Nailed Wooden Suns to Wooden Skies* was done in conjunction with his
1973 film *Hippodrome Hardware*, which relates the fantasy tale of his
building his grandmother's house using mammoth sized tools. In cartoon-
fashion, the picture distorts perspective and confuses scale while
displaying the anticipated element of absurdity—the invisible hand
nailing sun-shaped yellow boards to the air, while piles of miniature
furniture form tiny pyramids on a surreal landscape. The outsized
hammer is poised for action but it appears to float in space, with no
viable hand to wield it. This sense of play, of quixotic windmill-tilting and

buoyant enthusiasm, are characteristic of Grooms' entire oeuvre. One can
also detect Grooms' homage to Cubist and Abstract Expressionist
precedents capriciously divulged. The charm of Grooms' work lies in his
guileless attack on the sanctity of art, the minute attention that he pays to
details (as in the various pieces of discarded furniture that make up the
pyramids), and the sheer delight that exudes from his works. *I Nailed
Wooden Suns to Wooden Skies* epitomizes this joy, also attesting to the
quality of Grooms' craftsmanship and his sensitivity to materials and
colors.

N.E.G.

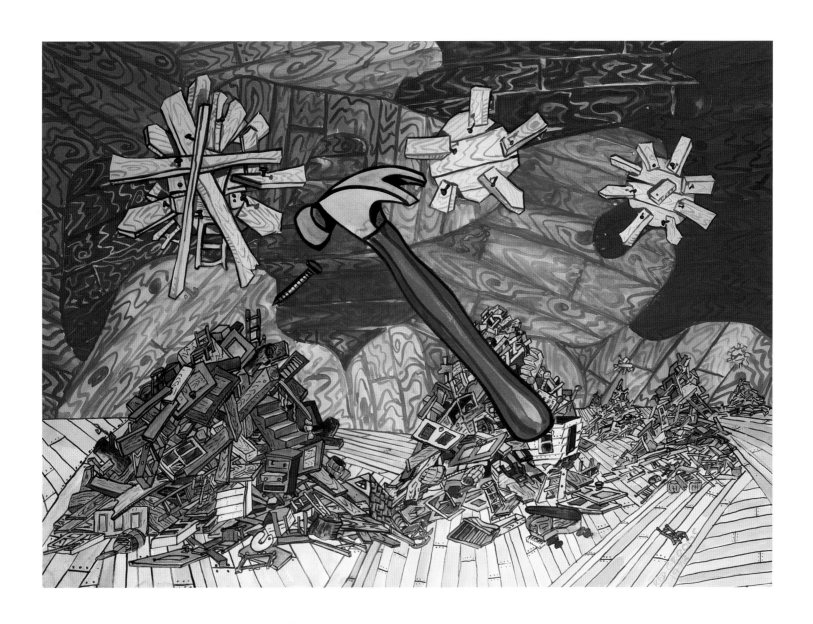

CHAIM GROSS (B. 1904)

28. *Crowded Beach*, ca. 1950s

Watercolor and pen and ink on paper
14½ × 22½ inches
Signed lower right: *Chaim Gross*

PROVENANCE
Estate of Esther Rabinowitz, New York

THE IMPORTANT modernist sculptor, Chaim Gross, emigrated
to the United States in 1921, following a childhood in Austria and
Hungary. Settling in New York, he enrolled at the Educational
Alliance, where his coterie included Phillip Evergood, Peter Blume,
Barnett Newman, Adolph Gottlieb, Saul Baizerman and Isaac and Moses
Soyer. An admirer of Elie Nadelman (who instilled in him an appreciation
for the beauty of line and pure form) and of Robert Laurent, (who
introduced him to the technique of direct carving) Gross began to create
abstract figural sculptures that owe to both influences: an expressive
formal language coupled with a respect for the media, as the essential
basis for aesthetic investigation. Although he is most well known for his
sculptural works, Gross has also worked in the graphic medium
throughout his career, filling countless sketchbooks with drawings and
making studies for three-dimensional works.

Crowded Beach, rendered in Provincetown, Massachusetts, where
Gross spent many summers following 1943, conveys the same vitality and
energy evident in his sculptures. Simplifying and distorting the contours
of his figures and emphasizing curves, Gross creates an exuberant
composition. By opting for a relief-style arrangement that conveys little
spatial depth, Gross exaggerates the feeling of crowding and reveals his
wry outlook on the scene.

The work's vitality is enhanced by Gross' technique. Transparent
washes of paint suggest the shifting pattern of clouds and the smoldering
heat of the summer afternoon. Recreation at the seaside drew the
attention of many nineteenth century American artists, in particular
Edward Potthast and William Merritt Chase. In his treatment of the
subject, Gross conveys the appeal of the beach to the urban masses of the
twentieth century, capturing its dense and teeming atmosphere as well as
its picturesque charm.

L.P.

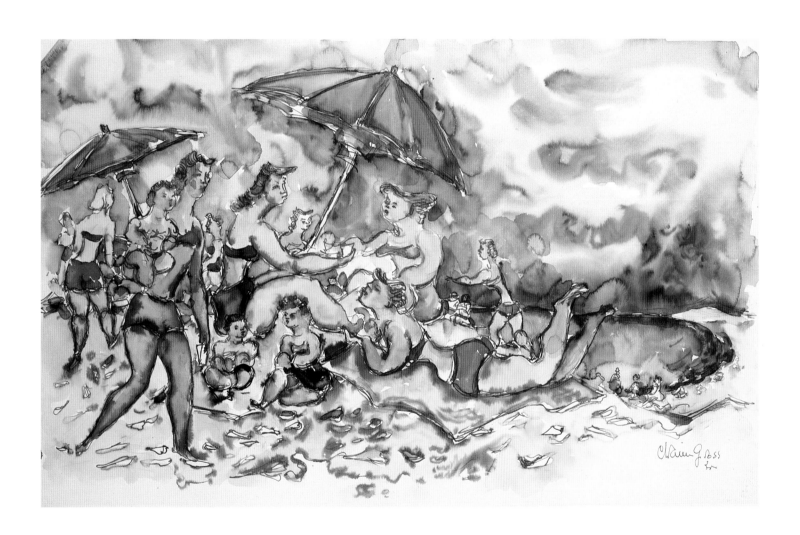

ELLEN DAY HALE (1855–1940)

29. *Musical Interlude*, ca. 1910s

Watercolor and gouache on green paper

13 × 16½ inches

Stamped lower left: *EDH* (in monogram)/*Ellen Day Hale/1855–1940./*
 Collection

Stamped lower right: *Estate/Ellen Day Hale/Collection*

PROVENANCE
Private Collection, Boston, Massachusetts

AN ARTIST ASSOCIATED with the first generation Boston
School, Ellen Day Hale painted portraits, figures, still lifes and
landscapes. She was also active as a muralist and photographer,
and was one of the most accomplished women etchers of her era.

Hale was a member of the Boston Brahmins, her family lineage
included such figures as the patriot Nathan Hale and the author Harriet
Beecher Stowe. She was the daughter of the esteemed Unitarian minister,
writer and orator, Edward Everett Hale and the older sister of the noted
Boston artist-critic, Philip L. Hale. Prior to studying in Paris, Hale was
taught by one of Boston's most influential artists, William Morris Hunt.

Although she is best known today for her easel paintings and her
prints, Hale was also a gifted watercolorist, exhibiting her work at the
American Society of Painters in Water Colors and at the Washington
(D.C.) Watercolor Club. Her earliest introduction to the medium came
from her aunt, Susan Hale, a gifted watercolorist and teacher.

In *Musical Interlude*, Hale has portrayed a young, unidentified
woman sitting on a bed of divan, her back propped up by several large
cushions. Captured in a moment of repose, the woman strums a guitar
while her dog sits next to her. The figure exists in a world all her own, her
eyes staring somewhat dreamily out into space, away from any direct
confrontation with the viewer. The informal nature of the scene reflects
the turn-of-the-century trend, especially among Boston artists, toward the
depiction of women engaged in leisure pursuits in indoor and outdoor
settings.

Hale's technique, notably her use of broad, translucent washes of
color, where line and detail are sacrificed in favor of a generalized
treatment of form, derives from her earlier studies under Hunt, who
urged his students to take a more poetic approach to their subjects, to
convey the "impression" of form rather than a purely descriptive realism.

Hale combines this approach with her own penchant for bold colors, in
this instance a vivid juxtaposition of red, pink, violet and green with
subsidiary tones of yellow and orange. *Musical Interlude* exemplifies
Hale's facility with watercolor, as well as her highly individual approach to
color and form.

C.L.

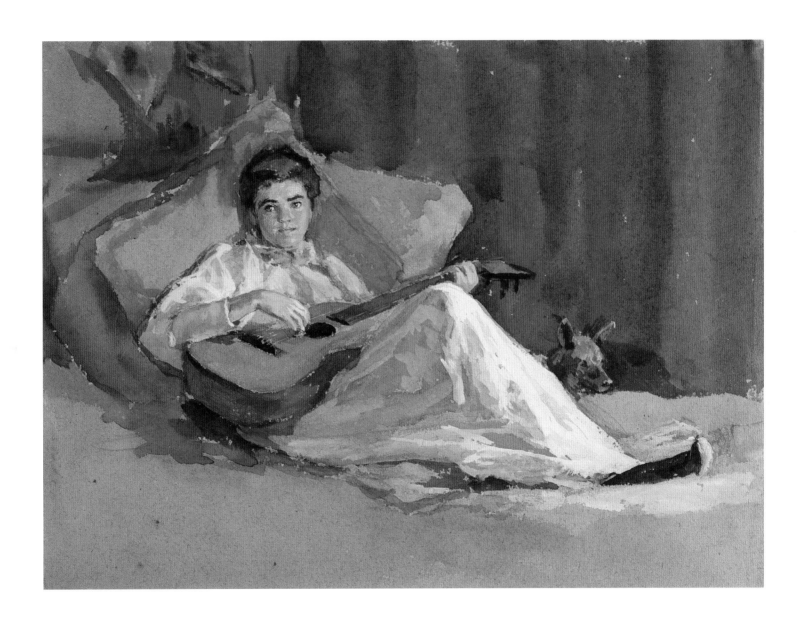

JOHN MCLURE HAMILTON (1853–1936)

30. *Standing Woman*, 1910

Pastel on paper
22½ × 17 inches
Signed and dated lower right: *Hamilton / 1910*

PROVENANCE
Private Collection, New York

BORN IN PHILADELPHIA, John McLure Hamilton began his artistic training at the Pennsylvania Academy of the Fine Arts. In the early 1870s he went to Europe, studying for two years at the Royal Academy in Antwerp under Joseph Henri François van Lerius. He continued his studies in Paris under the tutelage of Jean-Léon Gérôme at the École des Beaux-Arts. Returning to Philadelphia in the mid-1870s, Hamilton exhibited at the National Academy of Design and sent a work to the Paris Exposition of 1878. However, he remained in America only briefly. London became his domicile in the late 1870s, although he made numerous later visits to the United States. Hamilton specialized in potraiture, and he painted many of the important politicians and artists of his day. In 1921 he wrote *Men I Have Painted*, which is illustrated with reproductions of his works. He spent his last years in Jamaica.

Hamilton's academic background is evident in *Standing Woman*. With a very minimal application of pastel, he gives us a graceful and unusual depiction of his model turned in three-quarter view with her back to the observer. Blocking in her dress with spontaneous pastel notations, he conveys its floating skirt and delicate off-the-shoulder sleeve; her back is rendered with a more finished technique. In her somewhat mannered pose, the model presents a challenge. Hamilton conveys her elegance and poise, rendering the work with lightness and ease.

L.P.

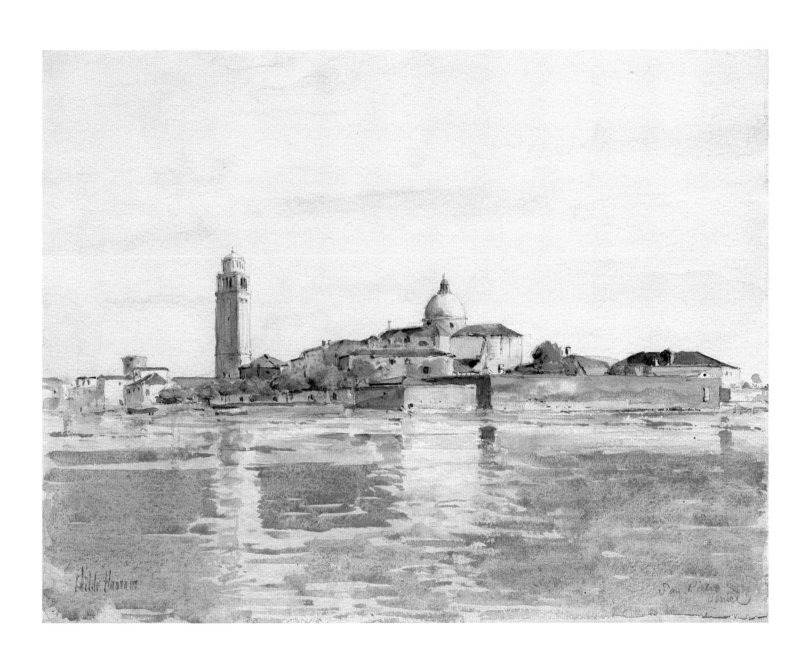

Childe Hassam San Pietro
 Venice

CHILDE HASSAM (1859–1935)

32. *East Gloucester*, 1918

Pencil and chalk on grey paper

8 × 11 inches

Signed, dated and inscribed lower left: *Childe Hassam / E. Gloucester/
July 3, 1918*

PROVENANCE

[Hirschl & Adler Galleries, New York, 1961]

Private Collection, New York

NOTE

This drawing will be included in the forthcoming catalogue raisonné now
in preparation by Stuart P. Feld and Kathleen Burnside.

"BEFORE I HAD SEEN Hassam's pictures [of Gloucester],
it seemed a fishy little city," wrote the artist Ernest Haskell,
"now as I pass through it I feel Hassam. The schooners
beating in and out, the wharves, the sea, the sky, these belong to
Hassam."[1]

Of all the sketching haunts along the Atlantic coast frequented by
Childe Hassam—the Isles of Shoals, New Hampshire, Gloucester,
Massachusetts, Cos Cob and Old Lyme, Connecticut and Easthampton,
Long Island, New York—Gloucester was a particular favorite. As early as
1880 or 1881 and for as many as ten summers during his prolific career, he
was drawn to the town's busy harbor, quiet coves and sandy beaches.

Hassam's pencil and chalk drawing *East Gloucester*, of 1918, looks
down on the intricate network of houses and docks of Rocky Neck and
across Smith's Cove to the less densely populated sector of East
Gloucester, where the artist often stayed. A compositional approach
common to Hassam and others who painted in Gloucester—Willard
Metcalf, Frank Duveneck, Joseph DeCamp and John Henry Twachtman—
was the elevated view and a high horizon line, both of which allow a
broad surface of detail within the picture space and an emphasis on flat
pattern. This was the period when Hassam was executing his famous flag
paintings, which also take an elevated viewpoint and concentrate on
formalist concerns. In addition, his graphic work in etching and
lithography of the mid to late teens strengthened his sensitivity to
structural design independent of color.

In *East Gloucester*, the flickering movement of quick pencil notations
highlighted with pink, yellow and white chalk strokes, masterfully evokes
the Impressionistic aesthetic that had become synonymous with Childe
Hassam by this time. A quiet fishing village has been transformed into a
sparkling vision of atmospheric beauty.

L.B.

1. Ernest Haskell quoted in *Portrait of a Place: Some American Landscape Painters
in Gloucester*, exh. cat. (Gloucester, Mass.: Cape Ann Historical Association, 1973,)
p. 62.

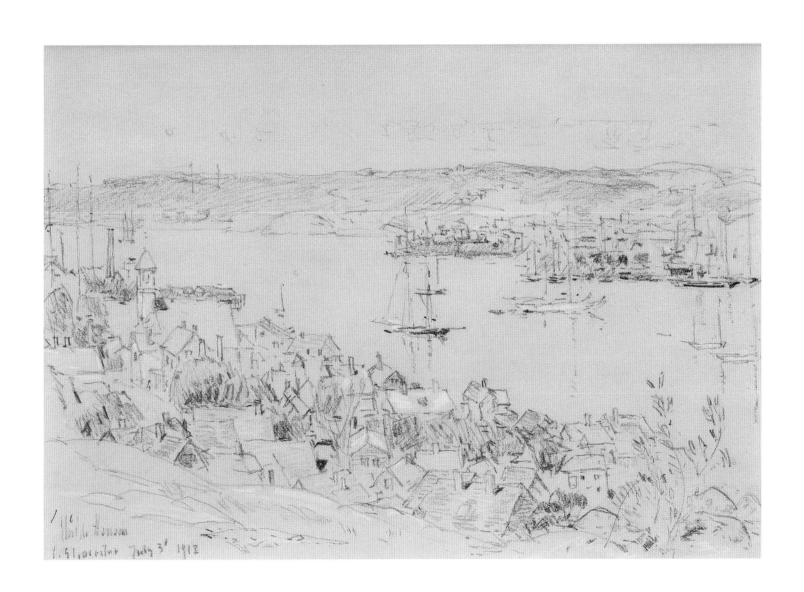

WILMONT EMERTON HEITLAND (1893–1969)

33. *Venetian Brooklyn*, 1922

Watercolor and pencil on paper
18½ × 19 inches
Signed and dated lower right: *Heitland 1922*

PROVENANCE
Private Collection, Florida

BORN IN SUPERIOR, Wisconsin, Wilmot Heitland received
instruction from Cecilia Beaux and Daniel Garber at the
Pennsylvania Academy of the Fine Arts. He also studied in New
York at the Art Students League, where he eventually became an
instructor of illustration. Heitland was the recipient of many awards,
including the Dana Gold Medal from the Philadelphia Water Color Club
(1921) and the Brown and Bigelow Purchase Prize from the Art Institute
of Chicago (1923).

Heitland's training under the Pennsylvania Impressionist Daniel
Garber no doubt encouraged his interest in pictorial effects and sparkling
color arrangements. In *Venetian Brooklyn*, his palette is especially
striking. He renders the wall of a weathered tenement building with blue
paint sponged into red. The white paper is carefully left bare to delineate
laundry hanging on lines, the columns on the narrow tower in the
distance, and broad expanses of open sky. Clouds are brushed in with
fresh blue pigment bled into the paper. In his choice of an urban subject
treated with attention to its picturesque possibilities, Heitland is heir to
the approach of the artists associated with the Ashcan School. Yet,
painterly surfaces and lively chromatic schemes suggest his stylistic
allegiance to the decorative mode of Post-Impressionism.

L.P.

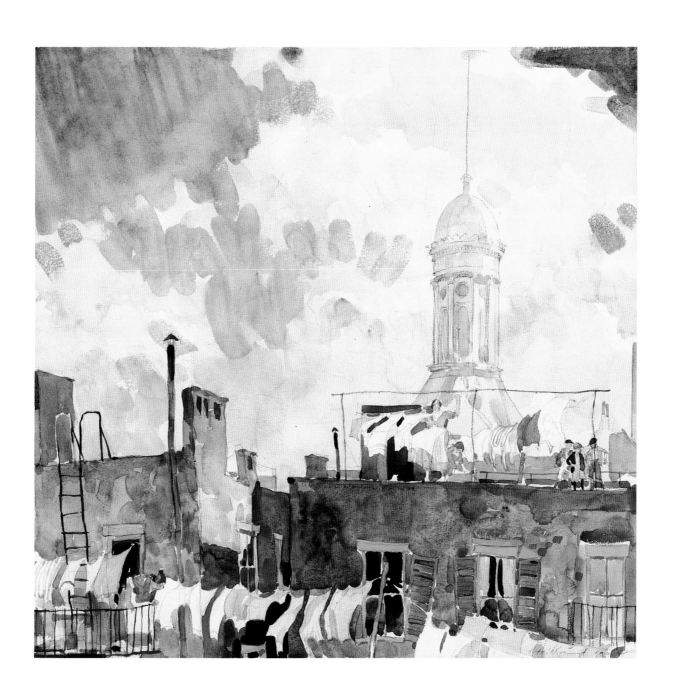

CARL ROBERT HOLTY (1900–1973)

34. *Untitled*, ca. 1938–1942

Watercolor and pencil on paper
12 × 9 inches
Signed with initials in pencil lower right and upper center: *C[.]H.*

PROVENANCE
Private Collection, New York

BORN IN FREIBURG, Germany, Carl Robert Holty was brought by his family to Milwaukee at age six and grew up in that Midwestern city. He studied at the Art Institute of Chicago and the National Academy of Design in New York, and had a professional career while still in his early twenties. Holty then decided to round out his education with a stint of travel and study abroad. In 1925–1926, he enrolled himself in Hans Hoffmann's school in Munich. In 1931 he was asked by Robert Delaunay to join the Paris-based group Abstraction-Creation. This organization, whose aim was to further abstract and non-objective art, included the greatest artists of the European avant-garde, from Piet Mondrian to Hans Arp. The invitation was quite an honor for a young American artist like Holty. Holty returned to the United States, however, settling in New York in the mid–1930s.

A close friend of Mondrian during the years the Dutch artist was in New York, and a teacher of Ad Reinhardt, Holty can be considered a major contributor to the development of abstract art in the twentieth century. He was a cofounder of American Abstract Artists (A. A. A.) and a highly regarded member during the years of that organization's greatest influence, from 1936 to about 1943.

For Holty, art was always a supremely serious endeavor, capable of revealing the fundamental nature of things. By the mid–1930s he had become most concerned with color and form. *Untitled* is a work that belongs to this first major period of his career, when he was synthesizing all he had learned from his European sources and creating a style of his own.

Elements of the art of Delaunay, Mondrian and even Arp might be seen in this watercolor and pencil drawing. For example, Delaunay's theory of color simultaneity is recalled in the juxtapositions here of red, yellow, and blue; Mondrian's idea of dynamic equilibrium is brought to mind by how the rhythm of the composition is established by the so-called empty space, the white of the page between the forms, as well as

the forms themselves; and Arp's notion of random order can be seen in the dispersive arrangement. The result, however, is more than the sum of any influences. It is Holty's expressive statement on the essential character of color and form, stressing the vitality of one and the force of the other. The overall structure seen in *Untitled* is found also in the painting *Orange and Gold* (1942; Whitney Museum of American Art, New York), a format, interestingly enough, that looks forward to the sweeping surfaces of Abstract Expressionism.

R.C.

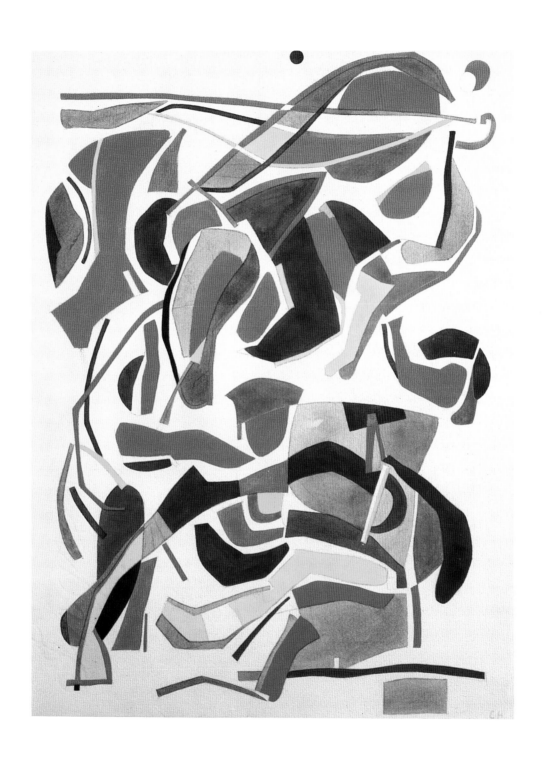

WINSLOW HOMER (1836–1910)

35. *Cavalryman with Sabre*, 1863

Charcoal and white chalk on toned paper
8¾ × 8 inches
Signed with initials and dated lower left: *W.H. '63*

PROVENANCE
Private Collection, New York State

NOTE
To be included in the forthcoming CUNY/Goodrich/Whitney catalogue
raisonné of the works of Winslow Homer.

WINSLOW HOMER, America's most prominent nineteenth century realist painter, began his career in 1855 as an engraver for the Boston lithographic firm of B. H. Bufford. Following three years of training, he turned to freelance illustration, working for such publications as *Harper's Weekly* and *Ballou's Pictorial Drawing-Room Companion*. During the Civil War, on assignment for *Harper's*, Homer visited the Union army in Virginia, where he created many vivid accounts of the battlefield and of daily life in the encampments. His images of the war also provided the impetus for some of his earliest and most well known oil paintings, among them the famous *Prisoner's from the Front* (1866; Metropolitan Museum of Art, New York).[1] Homer maintained the strong draftsmanship, the commitment to realism, and the unique personal vision reflected in his Civil War imagery throughout his career.

One of Homer's finest Civil War drawings, *Cavalryman with Saber* portrays a soldier concentrating his full energy on the battle scene before him. As in other Civil War works, for example *Sharpshooter* (1862–1863; Private Collection), Homer captures the suspended moment just before the subject strikes his foe.[2] Looking down from his horse, the soldier holds his sword in a raised position, his steady gaze on the scene below. Rather than presenting the drama and fierceness of war as in a traditional battle scene, Homer focuses on a human decision, conveying the calculation and precision involved in the soldier's action.

In his subject's cool poise and conviction, Homer avoids a heroic or sentimental presentation. His technique is similarly without excessive detail or artifice. The contours of the figure are rendered with energetic and assured lines. Shading, applied minimally but forcefully, contributes to the work's vigor. Touches of white chalk on the brim of the soldier's hat

and on his upraised hand suggest outdoor light and that the work was rendered from life. Executed with very economical means, Homer's *Cavalryman with Saber* presents a powerful and moving image of a soldier at war.

L.P.

1. For further information on Homer's Civil War imagery, see *Winslow Homer: Paintings of the Civil War*, exh. cat. (San Francisco: the Fine Arts Museum of San Francisco, 1988), with essays by Christopher Kent Wilson, Marc Simpson, Lucretia H. Giese, Nicolai Cikovsky, Jr., and Kristin Hoermann.
2. Three similar drawings of mounted Civil War soldiers are in museum collections; two belonging to the Cooper-Hewitt Museum, the Smithsonian Institution's National Museum of Design, and one belonging to the Museum of Fine Arts, Boston.

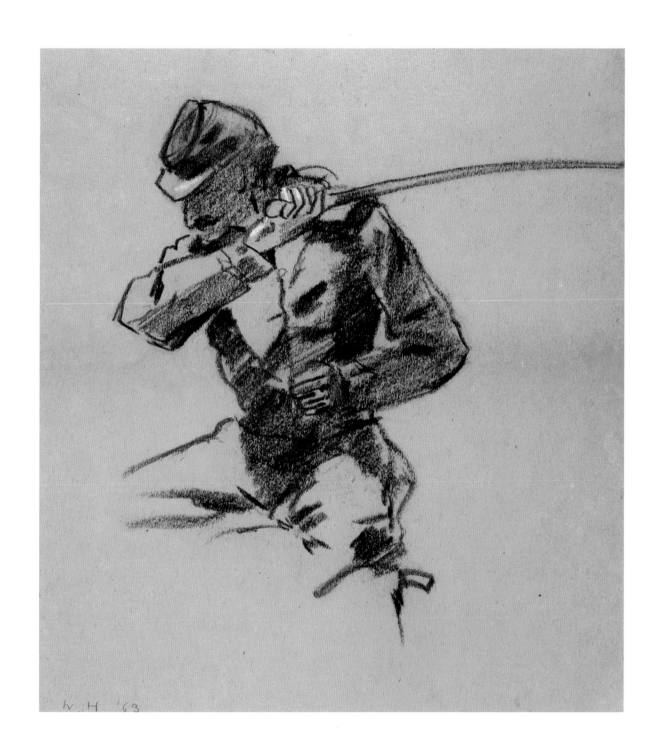

WINSLOW HOMER (1836–1910)

36. *Reflections*, 1880

Watercolor on paper
7¾ × 12¼ inches
Signed and dated lower right: *Homer 1880*

PROVENANCE
Mr. Kernan
G.W.H. Ritchie, son of the etcher and publisher, A.H. Ritchie
Edwin D. Hague, Cleveland, Ohio
Florence B. Hague, Brookline, Massachusetts
[Wildenstein & Co., New York, ca. 1948]
Robert F. Woolworth, New York, 1956
[Milch Gallery, New York]
Frederica F. Emert, 1958
George Peabody Gardner, III, 1976
[New York art market, 1976]
Dr. John E. Larkin, Jr., White Bear Lake, Minnesota, 1982
Private Collection, Texas

EXHIBITED
Rhode Island School of Design, Providence, *Watercolors by Winslow
 Homer*, 6 February–1 March 1931, no. 28.
Allied Art Association, Houston, *Winslow Homer Paintings, Watercolors
 and Drawings*, 17–26 November, 1952, no. 18.

NOTE
To be included in the forthcoming CUNY/Goodrich/Whitney catalogue
 raisonné of the works of Winslow Homer.

WINSLOW HOMER first visited Gloucester, Massachusetts in
the summer of 1873. It was during this trip that he began to
explore watercolor seriously. He returned to Gloucester in the
summer of 1880, when he again focused on the medium. While staying on
Ten Pound Island, which offered a peaceful and isolated existence in the
middle of Gloucester Harbor, Homer worked steadily. In the course of
the summer he produced over one hundred watercolors and drawings,
many of which were exhibited at Doll and Richards Gallery in Boston the
following December. The works created in the summer of 1880 reveal his
increased skill and confidence as a watercolorist, and in particular the
refinement of his *plein air* vision.

Reflections, a work from this period that belongs to a series of images
of Gloucester boys in boats, demonstrates Homer's new interest in
luminous effects.[1] Light and shadow, treated opaquely in earlier works,
are here expressed with broad and confident washes. Homer's handling is
loose, yet details, such as the masts of the sailboat in the center distance,
are rendered with delicate precision. Restricting his palette to silver grays
and soft blues, and allowing the white of the paper to establish the
brightest areas in the water and sky, Homer conveys the soft stillness of
the atmosphere and creates a harmonious and unified arrangement. The
composition appears informal, yet the spare design is complete.
Horizontal shapes are repeated across the surface, endowing the image
with a simple structure and a strong two-dimensional design suggestive of
Oriental art. Homer emphasizes formal issues over narrative and
anecdote, while at the same time demonstrating the concern with serious
subject matter and emotional expression which characterized his work
for the rest of his career.

L.P.

1. Works which relate to *Reflections* are in the collections of the Cooper-Hewitt
Museum and the Museum of Fine Arts, Boston.

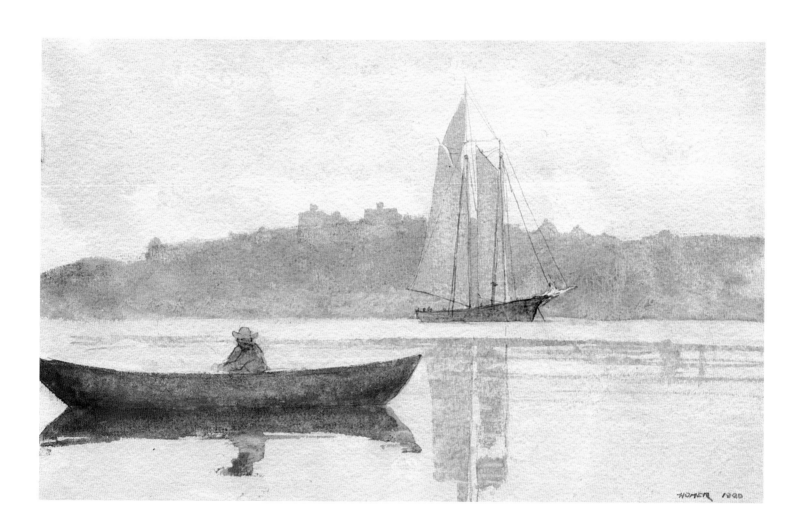

WINSLOW HOMER (1836–1910)

37. *Charles Savage Homer, Jr.*, 1880

Watercolor on paper
20½ × 15 inches
Signed with initials and dated lower left: *W. H. 1880*

PROVENANCE
The artist
Charles Savage Homer, Jr., the sitter and the artist's brother
Mrs. Charles Savage Homer, Jr., his widow
Charles Lowell Homer, Prout's Neck, Maine, son of the artist's brother
 Arthur Homer and nephew to Winslow Homer and Charles Savage
 Homer, Jr.
Alice Homer Willauer, daughter of Charles Savage Homer, Jr.
Peter O. Willauer, her son
Private Collection, Washington, DC

EXHIBITED
Bowdoin College Museum of Art, Brunswick, Maine, *The Art of Winslow
 Homer, An Exhibition Sponsored Jointly by the Art Departments of
 Bowdoin and Colby Colleges*, 1–21 November 1954. The exhibition
 was subsequently shown at the Women's Union of Colby College,
 Waterville, Maine, 1–21 December 1954.
Portland Museum of Art, Portland, Maine, Fiftieth Anniversary
 Exhibition, 1960.

LITERATURE
Gordon Hendricks, *The Life and Work of Winslow Homer* (New York:
 Harry N. Abrams, Inc., 1979), illustrated p. 137, pl. 214 and p. 169,
 pl. 264.

NOTE
To be included in the forthcoming CUNY/Goodrich/Whitney catalogue
 raisonné of the works of Winslow Homer.

WINSLOW HOMER had an unusually close relationship with
his brother Charles, who was two years older. Charles,
following his graduation from Harvard, established a career as
a chemist, eventually becoming a partner in the Valentine Varnish and
Paint Manufacturers Company, was in turn devoted to his younger

brother and was a fervent supporter of his art. Charles purchased the first
two paintings which Winslow exhibited, and he continued to collect his
sibling's work at every opportunity. The brothers shared an interest in the
outdoors, and their bond was strengthened by the many trips they took
together to the wilderness to hunt, fish and camp. In fact, many of the
sportsmen depicted in Winslow's paintings were modeled on his brother.

Dressed in an elegant gray pin-striped suit and a crisp white shirt, in
this portrait Charles is shown in a much different guise from that of the
intrepid athlete who appears in Winslow's scenes of outdoor life. The
portrait brings out Charles' brawny build and his handsome ap-
pearance—his carefully groomed mustache, his neat haircut, and his
freshly shined shoes. The subject's arm rests authoritatively on a fur-
covered chair, his direct gaze conveying conviction and a reflective
nature. The portrait presents Charles as urbane and debonair, but also as
a man of intellect and sensitivity. His gracefully posed hands denote an
artistic sensibility, perhaps suggesting the way he approached scientific
endeavors. Undoubtedly created as a gift for his brother, the work exudes
the admiration that Winslow felt for Charles. At Charles' death, the
painting became the possession of his widow, Mattie Savage Homer, with
whom Winslow also had a close friendship and thereafter it passed by
descent through the family.

Technically, the work displays the artistry that Homer had achieved
in watercolor by 1880, as his awareness of the potential of the medium
grew. Rather than covering the surface with thick layers of paint, he had
begun to employ transparent washes to lend softness to objects and to
convey effects of light. Here, he expresses the mottled texture of the fur
coat or shawl that covers the chair by varying the opacity of the pigment.
Charles' gray suit is also rendered with a soft wash of color, overlaid with
thin lines that establish the striped pattern. Fluidly applied color bled
into the paper establishes the background. The work's tonal unity, the
careful placement of forms in space, and the sidelong pose of the figure
suggest Homer's awareness of the work of James McNeill Whistler.
However, the formal strengths do not detract from the work's emotional
intent—a tribute bestowed by one brother to another.

L.P.

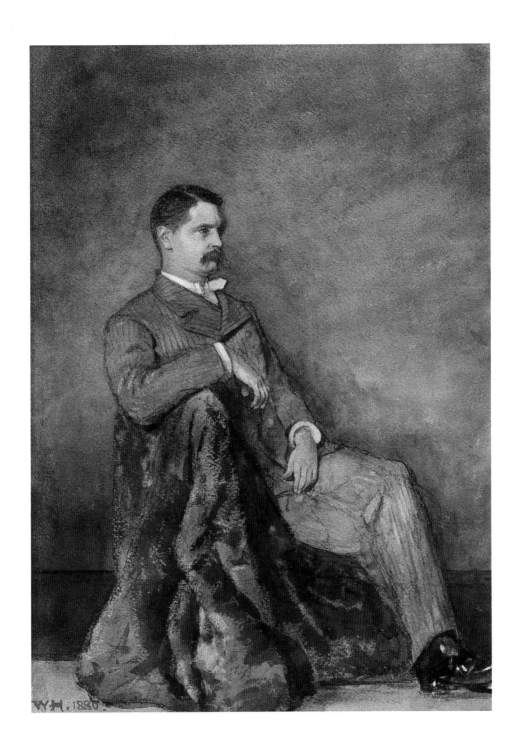

EDWARD HOPPER (1882–1967)

38. *Trawler*, 1924

Watercolor over pencil on paper
13¼ × 19¼ inches
Signed lower left: *Edward Hopper*
Inscribed and dated lower left: *Gloucester 1924*

PROVENANCE
[Possibly J.B. Newman, New York]
Dr. Franz Hirschland, Westchester, New York, ca. 1929
Gift of Dr. Hirschland to Private Collection, Connecticut

NOTE
This work is to be published in Gail Levin's forthcoming *Edward Hopper:
A Catalogue Raisonné*

BORN IN NYACK, New York, along the Hudson River, Edward
Hopper was attracted to the water at an early age and even briefly
considered a career as a naval architect. He studied art in the local
schools before seeking instruction at the New York School of Art under
Robert Henri and Kenneth Hayes Miller, both of whom urged their
students to concentrate on scenes of contemporary life. Between 1906 and
1910, Hopper made three European visits of several months each,
spending most of his time in Paris, where he absorbed the style of the
Impressionists into his early work.

Hopper began to summer in Gloucester, Massachusetts, in 1912, first
choosing picturesque subjects of the waterfront and the rocky shores as
seen from a distance. Each time he returned to the village, however, he
probed deeper into Gloucester's inner life. During the summers of 1923
and 1924, close-up views of mansard roofs, the rusty trawlers and other
symbols of the town's past came under his scrutiny. Watercolor was now
his main interest—he had resolved to give up printmaking and
illustration work during the previous years—and it was with the
Gloucester watercolors that Hopper found his first success with the New
York critics. "We rejoice that he is using the medium,"[1] wrote one
reviewer while another praised the works' "vitality and force and
directness" as examples of "what can be done with the homeliest subject
if only one possesses the seeing eye."[2]

Trawler, a watercolor of 1924, is part of a series Hopper produced on
the subject.[3] It presents an intimate view of the bridge and rigging of the

relic of the local fishing fleet, the trawler, whose crews eeked out the most
minimal livelihood dragging nets along the coastal waters. The artist
frames the scene with two obliquely positioned lifeboats, their curving
lines leading toward the large smokestack in mid-center. Through the
railing of the upper deck we glimpse the housetops of Gloucester, one of
which reveals a "widow's walk."

Matching technique to the ruggedness of the ship, Hopper uses
washes of gray, blue-black and touches of beige to model its shapes,
revealing in its appearance a memory of misty days at sea. The same artist
who celebrated the lonely lighthouses and weathered seaside mansions of
Gloucester took great pleasure in rendering another tireless remnant of
the town's fishing tradition, the old and rusty trawler.

L.B.

1. Royal Cortissoz, "A Fine Collection at The Brooklyn Museum," *New York Tribune*
25 November 1923, p. 8.
2. Helen Appleton Read, "Brooklyn Museum Emphasizes New Talent in Initial
Exhibition," *Brooklyn Daily Eagle* 18 November 1923, p. 2B.
3. Others in the series include *Bow of Beam Trawler* (1923, Private Collection), *Two
Trawlers* (1923–1924, Whitney Museum of American Art, New York) and *Beam
Trawler Teale* (1926, Munson-Williams-Proctor Institute, Museum of Art, Utica,
New York).

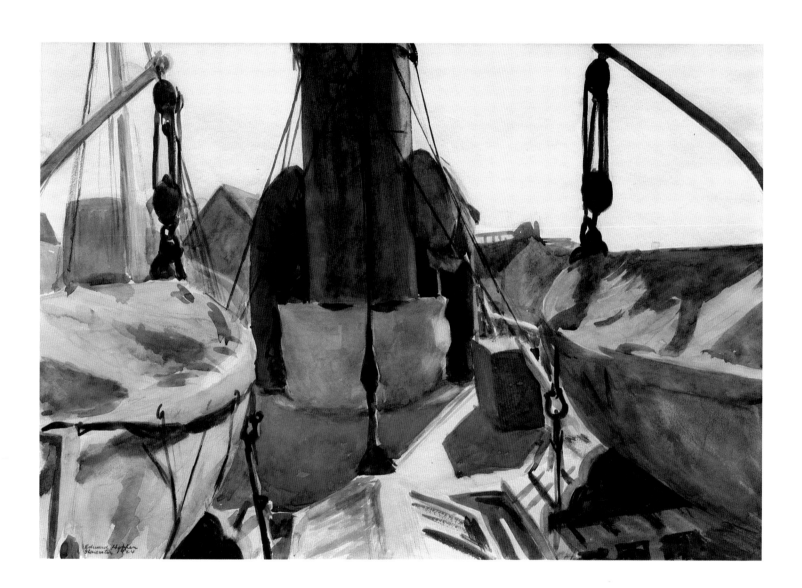

THOMAS HOVENDEN (1840–1895)

39. *What O'Clock Is It?*, 1876

Watercolor and gouache on paper
4 × 6⅜ inches
Signed and dated lower right: *Hovenden/1876*
Inscribed lower left: *Brittany*

PROVENANCE
Julia and Loomis Havemeyer, until 1971
Private Collection, Louisiana

NOTE
This work is a study for *What O'Clock Is It?* (1878, Oil on canvas,
38 × 53 ½ inches, formerly in the collection of Storm King Art
Center, Mountainville, New York; also known as *Summer Afternoon*
and *A Brittany Peasant Girl*).

THOMAS HOVENDEN, one of the most popular and important
genre painters of late nineteenth century America, was born in
Dunmanway, County Cork, Ireland. After an apprenticeship to a
carver and gilder and evening classes at the Cork School of Design, he
emigrated to America in 1863.

Hovenden returned to Europe in 1874, when he went to Paris to
study the figure under Alexandre Cabanel at the École des Beaux-Arts.
For most of his years spent abroad, however, he was drawn to the artists'
colony at Pont Aven, where he joined the acknowledged leader of the
group, Robert Wylie, and his longtime friend, Hugh Bolton Jones. In
Brittany, he produced the best paintings of his early career, including
Breton Interior: Vendean Volunteer, The Image Seller, Brittany and *What
O'Clock Is It?* (also known as *Summer Afternoon* and *A Brittany Peasant
Girl*).

The first two works show Wylie's characteristic handling and interior
settings. *What O'Clock Is It?*, a depiction of a Breton woman lounging in
the open air, pursues a more naturalistic course, somewhere between
Hovenden's academic training and his response to the *plein-air* lightness
of Impressionism.

What O'Clock Is It?, a watercolor study for the painting of the same
title, was executed in 1876, two years after Hovenden's arrival in France.
It typifies the artist's use of watercolor during this time in its controlled
style, utilizing carefully applied washes and gouache within the shapes

defined by the initial graphic understructure. The young girl, in Brittany
costume, is shown resting in a sunny clearing near a deep woods. She is
propped on her elbows and holds in her left hand a single dandelion,
which is in the downy stage ready to be dispersed by the wind. Her
shadowed gaze is glued to the flower as she blows, with puckered mouth,
the last wisps from the pod.

Blowing dandelion seeds to the wind has a special significance in
Europe for "telling" the time of day. Depending on the number of puffs
necessary to dissolve the final stages of the flower, one is able to assign the
hour: one blow equals one o'clock, two puffs means two o'clock and so
on. Thus the nickname for the common dandelion is the what's o'clock.

Hovenden's *What O'Clock Is It?* clearly refers to this age-old game
and reveals a lesser known aspect of the artist's realism, one in which he
celebrates the people of Brittany not as subjects of the historically
picturesque but as individuals with familiar concerns, engaged in
everyday activities.

L.B.

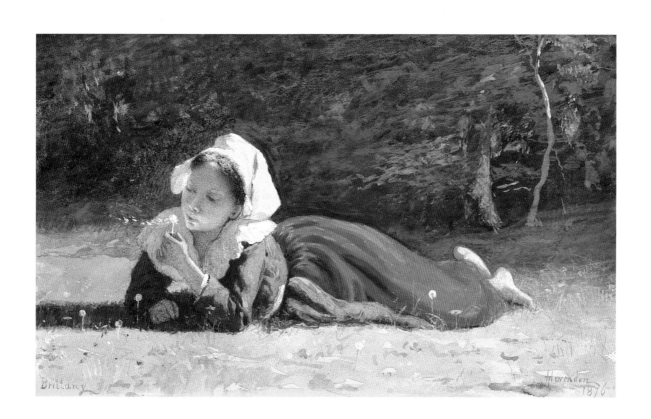

WILLIAM MORRIS HUNT (1824–1879)

40. *Nightfall*, ca. late 1860s–1870s

Charcoal on paper
6¼ × 10 inches
Signed with initials lower left: *WMH*

PROVENANCE
Estate of the artist
[Sale: Horticultural Hall, Boston, February 1880, No. 13]
Private Collection, New York

RECOGNIZED AS BOSTON'S foremost painter of the 1860s and 1870s, William Morris Hunt was one of the first American artists to be influenced by contemporary French art. Inspired by the work of Thomas Couture, J. F. Millet and the Barbizon School, Hunt helped gain acceptance in Boston of a more suggestive, less literal approach to painting at a time when most American artists were still conforming to the descriptive realism of the Hudson River School.

Although he had initially planned to become a sculptor, Hunt decided to study painting after seeing the work of Couture, one of France's most progressive painters, an opponent of the academic style. Hunt studied under Couture from 1846 until 1852, during which time he was profoundly influenced by his teacher's painterly technique. During 1852–1853 and again in 1855, Hunt painted with J. F. Millet at Barbizon, where he was inspired by the Frenchman's direct, spontaneous approach to nature and his emphasis on rural subjects. Hunt returned to Boston later in 1855. He moved to Newport a year later but resettled in Boston in 1862, focusing then on portraiture and figure studies.

In May of 1866, Hunt and his family left Boston for a lengthy trip to Europe. In addition to visiting Paris, Hunt also went to Dinan, in Brittany, where he fraternized with the expatriate artists Elihu Vedder and Charles C. Coleman. It was during this period that Hunt began to explore the expressive possibilities of charcoal, a medium he had used only occasionally. Later, when reminiscing about the box of charcoal he purchased in Paris, he stated "I give you my word, that box was the beginning of all the charcoal drawing that's been done in America . . . I took it down to Brittany with me and liked it very much."[1]

Hunt also traveled to Barbizon, spending time with Millet and J. B. C. Corot before returning to Boston in the spring of 1868. He soon began to take a greater interest in landscape subjects, which he rendered in charcoal as well as oil. Hunt's *Nightfall* exemplifies the type of evocative, small-scale landscape study he would produce throughout the next decade.

Nightfall, which features a view of an isolated house in an unidentified landscape, might possibly have been drawn in France or in one of Boston's suburbs, such as Milton, Newton or Watertown, where Hunt made frequent sketching trips. The image has been freely rendered with the broad side of the charcoal stick, while its sharper point has been used to delineate the roofline of the house and the thin branches of the trees. In addition to illustrating Hunt's assimilation of Couture's aesthetic, *Nightfall* demonstrates several of the artistic precepts that Hunt passed on to his students in Boston. Indeed, the soft atmospheric fluency of *Nightfall* illuminates his recommendation to "sacrifice as many details as possible," for "it's the impression of the thing that you want."[2] In his promotion of this attitude, Hunt, along with such contemporaries as George Inness and George Fuller, helped create the trend, during the 1870s, toward a more poetic approach to nature.

C.L.

1. William Morris Hunt quoted in Helen Knowlton, comp., *W.M. Hunt's Talks on Art: Second Series*, 1883, reprint (Boston: Houghton Mifflin, 1911), p. 7.
2. Hunt quoted in Helen Knowlton, comp., *W.M. Hunt's Talks on Art* (Boston: Houghton Mifflin, 1875), p. 61.

HUGH BOLTON JONES (1848–1927)

41. *Edge of the Stream*, ca. 1870s

Watercolor on paper
13½ × 17 inches
Signed lower right: *H. Bolton Jones*

PROVENANCE
Private Collection, Seattle, Washington

Jones made his reputation on his depictions of the seasons. *Edge of the Stream*, with its fluid overlays of vibrant color glazes, records the transitional effects of autumn's metamorphosis and serves as a meditation on the never-ending cycle of nature's decay and joyous rebirth.

L.B.

LANDSCAPIST HUGH BOLTON JONES was born in Baltimore in 1848. He studied at the Maryland Institute in that city, probably under the portraitist David Acheson Woodward, and later in New York City, under Horace W. Robbins and Carey Smith. Jones' first landscapes were drawn from his sketching excursions to West Virginia, the Berkshires and a four-month tour of Europe, and were exhibited at the National Academy of Design beginning in 1867.

A later trip to Europe began in 1876, during which time he is said to have studied briefly at the Académie Julian. He spent most of his time, however, at the artists' colony in Pont Aven, Brittany, with fellow Americans Robert Wylie, Thomas Hovenden and William Lamb Picknell.

Jones' landscapes from his European period often include the local peasantry and native architecture. His watercolor *Edge of the Stream* beautifully captures the quiet environs of a European farm as seen from a nearby brook. We are led into the scene through the gentle curves of the waterway, its shoreline dense with the tangled growth of autumnal shrubs and barren tree trunks. Only the last dry leaves of summer cling to the wiry branches that stretch their limbs towards the gray-blue sky. The most significant feature of Jones' landscapes, however, as seen in *Edge of the Stream*, is the crisp clarity of still water as it mirrors the luminosity of the sky and reveals the richness of the reflected foliage. To achieve this in watercolor, using the white of the paper as the reflective surface, is particularly impressive. The freshness of the color—rich blue-green, ochre and violet—contributes to a perception of aliveness and to the revelation of an inner spirit, as noted by critic Walter Montgomery:

> Mr. Jones' pictures always appear to us to have meaning and significance of a deep and valuable sort; to penetrate beyond the surface of the scenes of which they are representations; and to bring out and forward some of the inner and fascinating truths.[1]

1. Walter Montgomery, ed., *American Art and American Collections* (Boston: E.W. Walker & Co., 1889–1900), p. 936.

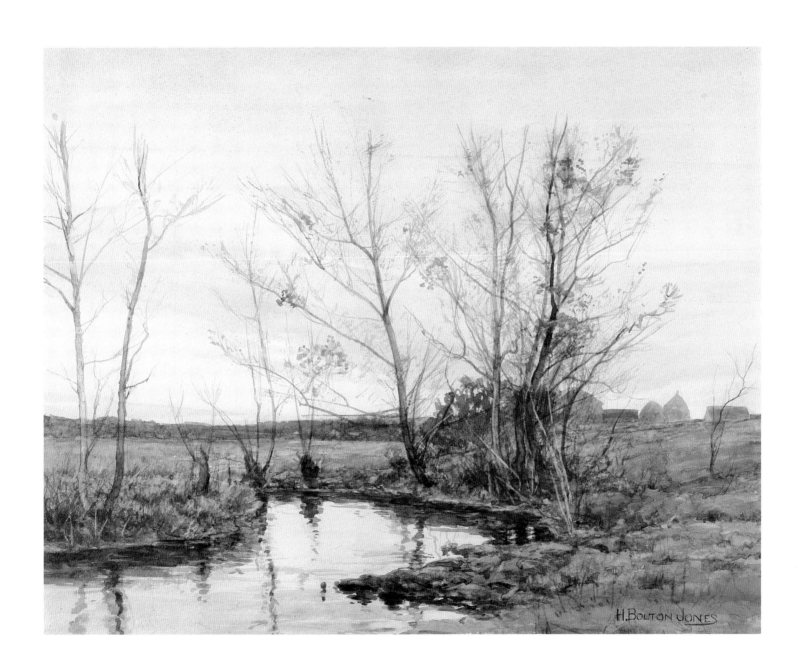
H.BOLTON JONES

CHARLES SALIS KAELIN (1858–1929)

42. *Boats in Harbor*, ca. 1910s–1920s

Pastel on paper

13½ × 16½ inches

PROVENANCE

Private Collection, Cincinnati

CHARLES KAELIN, a noted pastelist, was one of the earliest American exponents of Divisionism. A respected member of the art colony at Rockport, Massachusetts, Kaelin's colorful renderings of Cape Ann scenery were championed by many of his fellow artists, including Frank Duveneck, one of the first to recognize the high quality and innovative nature of his work.

The son of a Swiss lithographer, Kaelin was born in Cincinnati in 1858. Following in his father's footsteps, he entered a local lithographic firm at the age of sixteen. Kaelin later attended the McMicken School of Design in Cincinnati and the Art Students League in New York. During this period, Kaelin established close friendships with a number of influential Cincinnati-based artists, including Frank Duveneck and John Henry Twachtman (with whom he is thought to have studied).

Kaelin remained in New York throughout the 1880s and early 1890s, working as a lithographer and painting during his spare time. Returning to Cincinnati in 1892, he joined the Strobridge Lithographic Company as a designer of theater posters, calendars and other forms of advertising art. He also went on painting trips throughout southern Ohio, portraying the landscape in a delicate, poetic manner, reminiscent of Twachtman. He received his earliest critical recognition in 1899, when the Cincinnati Art Museum organized a solo exhibition devoted exclusively to his pastels.

Kaelin made his first trip to Gloucester in 1900. While he first spent only summers on Cape Ann, while continuing his work in lithography the rest of the year, Kaelin moved permanently to Rockport in 1916, a year after being awarded a silver medal at the Panama-Pacific Exposition.

The "hermit painter," as he came to be known to the local citizenry established his studio in a small fishing shanty facing the harbor and spent his days painting and sketching in and around Rockport. He did little to promote his work, and his economic survival often depended on sales arranged by artist friends such as Duveneck. Although his Cape Ann subjects included seascapes and views of sites that have since become known as "Kaelin's Woods" and "Kaelin's Brook," he was particularly fond of rendering the sun-dappled harbors of Rockport and Gloucester. After a visit to Cape Ann in 1927, the Cincinnati-based painter John Weis recalled: "Gloucester to the painter will always be Gloucester as long as the boats are in the harbor. Kaelin never wearies of painting it, and his things have the true Gloucester spirit."[1]

While demonstrating Kaelin's facility with pastel, *Boats in Harbor* also exemplifies Kaelin's mature style, in which he combines an Impressionist's concern for light and atmosphere with technical strategies associated with early twentieth century modernism.

The scene is a typical New England harbor featuring three fishing vessels moored alongside a weather-beaten dock. A number of shacks and shanties can be discerned in the background. Kaelin portrays these forms using a rich, vivid chromaticism consisting of an array of unmixed blues, greens, yellows and oranges. He applies his chalk with a series of long, interwoven strokes of varying lengths and density, creating a luminous, tapestry-like effect which is enhanced, and unified, by the underlying tan of the paper which emerges throughout the composition. Kaelin's divisionist technique endows the composition with a strong sense of patten and structure, while his vibrant coloration and his use of white highlights, especially on the fishing boats, conveys the effects of shimmering, late afternoon light as it falls across each form.

C.L.

1. John Weis quoted in an unsourced news clipping, dated 11 September 1927, photocopy in the Charles Kaelin documentation file, Spanierman Gallery.

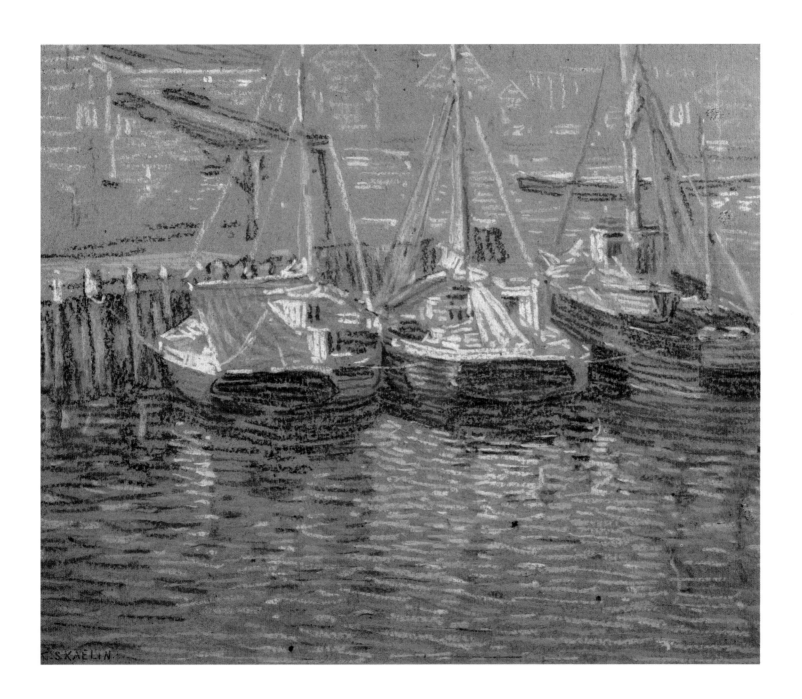

FRANZ KLINE (1910–1962)

43. *Feline*, ca. 1940s

Brush and black ink on paper
11 × 8½ inches
Signed with initials lower right: *FK* (in monogram)

PROVENANCE
Cass Canfield, New York
[F.A.R. Gallery, New York]
[Herbert E. Feist Gallery, New York]
Private Collection, New York

FRANZ KLINE ranks alongside of Jackson Pollock and Willem de Kooning as one of the creators of Abstract Expressionism, the movement that on many levels can be credited with determining the course of contemporary art. With their characteristically bold, slashing images, Kline's black and white canvases of the early 1950s remain an embodiment to the heroic ethos that surrounded Abstract Expressionism, which called upon artists to do battle against previously established artistic traditions by inventing a new, richer language of pictorial representation.

The route Kline took to Abstract Expressionism was, for the founding group, a bit unusual. It was via his interests in figurative art and illustration that Kline came to his Abstract Expressionist vision.

Kline was always keen about drawing, and he held artists who drew well in the highest esteem. He was known, for instance, to have been a fan of such American painters as Edward Austin Abbey and James Whistler and of British illustrators Steven Spurrier and Charles Samuel Keene. But by the mid–1940s, while Kline was living the artist's life in downtown New York, his serious time in the studio was devoted to working his way out of the figurative tradition that he had studied at the Boston Art Students League and Heatherly's School of Fine Art in London. The drawing *Feline* can be identified on the basis of style, subject and the cartouche-like signature (containing the artist's initials, FK, turned back-to-back), as belonging to this watershed period.

In *Feline*, Kline's background in the art of illustration comes through in the sure and rapid-fire execution of the portrayal of a cat captured in the instant of moving forward. The cat might well be Kitska. According to a recent monograph on Kline, Kitska was a gift from the artist to his wife Elizabeth. Kitska lived with Kline until the mid–1940s, when she ran away from friends who had taken her on a summer vacation in upstate New York. Though Kline himself made a trip upstate to find the cat, he was not successful.[1]

In drawings like *Feline* Kline began to discover how his direction as an artist lay in getting in touch with his own gestural impulse, in focusing on its expressive strengths. Here this impulse can be recognized in the lively treatment of the contours of the cat's neck, back and tail, in the way these are rendered with freedom and feeling. The sensuous curves of the cat's body are indicated not only by subtly brushed passages of black ink but also by the white of the page, prefiguring the use of white as positive shape that is another feature of Kline's Abstract Expressionist style.

R.C.

1. Harry F. Gaugh, *The Vital Gesture Franz Kline* (New York: Abbeville Press, 1985), p. 166 n. 19 (see p. 41 for photo of Kline holding Kitska).

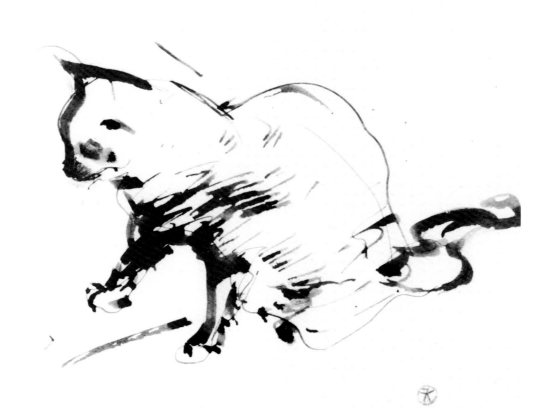

BLANCHE LAZZELL (1878–1956)

44. *Tabletop Still Life*, 1944

Gouache, watercolor and pencil on paper
10⅝ × 8⅜ inches
Signed and dated lower right: *Blanche Lazzell, 1944*

PROVENANCE
Private Collection, Florida

BLANCHE LAZZELL, born in Maidsville, Virginia, attended West Virginia Wesleyan college (then West Virginia Conference Seminary) and received her degree in 1898. At South Carolina Co-Educational Institute and West Virginia University she received an additional degree in drawing, painting and art history in 1905. In 1908 she studied with William Merritt Chase at the Art Students League, and from 1912 to 1914 went to Paris to receive instruction at the Académie Moderne. In 1915 she established a studio in Provincetown, Massachusetts, where she became actively involved with the Provincetown printmakers, including B. J. O. Nordfeldt, William and Marguerite Zorach, George Ault and Karl Knaths. Although she continued to travel and study abroad after the war, Provincetown remained her home until her death in 1956.

Though trained in the traditional American methods of artistic expression, Lazzell arrived at an abstract style that seems to have appeared full-blown, in mid-career, without any of the expected intermediate work in a semi-abstract mode. On her first visit abroad since the war, she settled down in Paris, to study with Albert Leon Gleizes, André Lhote and Fernand Léger. Whatever her previous feelings about modernism, in 1923 she willingly embraced all that these three artists could teach her about decorative, geometric Cubism. The result was some of the earliest American work in this abstract vein, work that was exhibited at the Paris Salon through the 1930s.

These early works served as precedents to later abstract pieces, such as *Tabletop Still Life*. In this 1944 watercolor and gouache, Lazzell's style has matured, and we can see the previous influence of Cubism—the strong geometric shapes, bold colors and sharp angles. These elements are innovatively juxtaposed with areas of mottled pastel color and glowing pure whites that suggest the flowers of her own garden. This work is a beautiful example of how Lazzell resolved the dichotomy between the sophistication of the Cubist aesthetic and the bohemian quality of her life in Provincetown. The broad, startling areas of black encompass the softer shades of the table and the still life arrangement. It is this tension between the light and the dark, the hard and the soft, the bold and the demure, that creates a composition of great intensity and feeling.

N.E.G.

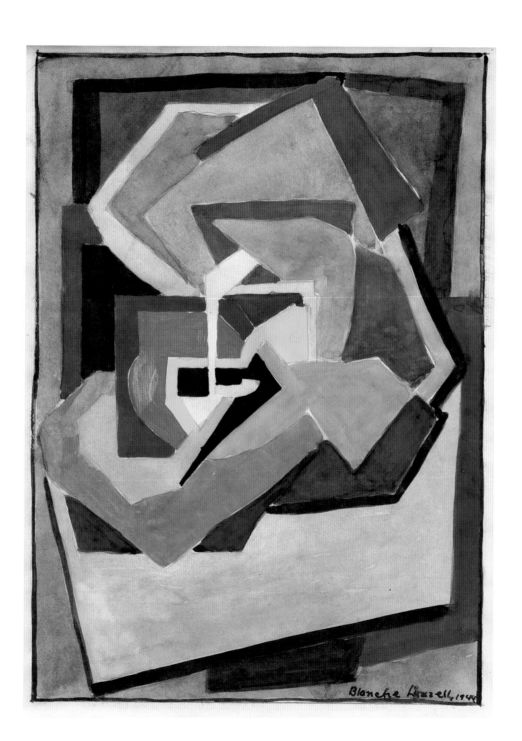

MARTIN LEWIS (1881–1962)

45. *Night Windows*, ca. 1925–1929

Graphite on toned paper
10⅞ × 8⅜ inches
Stamped with estate stamp verso

PROVENANCE
Estate of the artist
Mrs. Lucille Deming Lewis, the artist's wife
Patricia Lewis, the artist's daughter-in-law
Private Collection, Connecticut

MARTIN LEWIS, born in Australia, arrived in New York at the turn-of-the-century. A gifted painter, printmaker and draftsman, Lewis was widely admired by his contemporaries as one of the leading interpreters of a popular subject: the modern American city. His views of New York City from the late 1920s, shown at a retrospective given by the Kennedy Galleries in 1929, earned him considerable acclaim for the fresh ways they captured the dynamic spirit of metropolitan life.

Stylistically, *Night Windows* dates from those years, 1925–1929, a period that marked an important breakthrough in Lewis' career and that found him in the vanguard of the movement to free American realism from the anecdotal and overly descriptive traditions of European genre art. Like his friend Edward Hopper, Lewis during this period developed realism into a powerful pictorial language.

The touchstone for all Lewis' work was his drawing. He drew incessantly from life and used these studies to compose his prints and paintings. *Night Windows*, however, is not known to be a study for any other work.

Night Windows presents a group of neighboring buildings as monumental forms. The low angle from which they are seen highlights their massiveness, and their weight and solidity are stressed by Lewis' heavy line. The lines projecting from the roofs and fire-escape add an element of scale that further enhances the towering stature of the buildings. In stark contrast is the single tiny figure, a woman silhouetted against one of the illuminated windows. This expressive image conjures anxious feelings about the significance of the space defined by one's apartment, building and street, and about the place of the individual in the modern metropolis.

R.C.

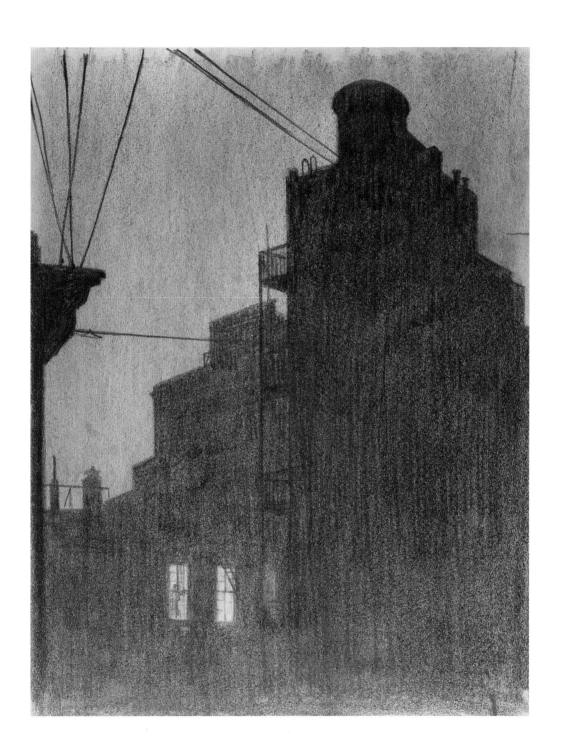

JACQUES LIPCHITZ (1891–1973)

46. *The Road of Exile*, 1941

Watercolor, gouache and pen and india ink on toned paper
11½ × 9⅞ inches
Signed upper right: *J. Lipchitz*

PROVENANCE
Acquired from the artist
Private Collection

FOR THIRTEEN MONTHS starting in May of 1940, Jacques Lipchitz and his family were refugees. Forced to leave Paris because of its imminent occupation by the Nazis, they went first to Toulouse and the rather tenuous security of the free zone' of France. In June 1941, with their arrival in New York, they found safe haven in the United States.

The Road of Exile is one of three works, all related, that Lipchitz made in response to this situation, the others being *Flight* (1940) and *Arrival* (1941). This piece is from 1941, that is, after *Flight*, which was made in Toulouse, and sometime before *Arrival*, the first piece made in New York. It is a fascinating enrichment of the form and idea introduced in *Flight*.

Like *Flight*, *The Road of Exile* is a composition with two figures, a man and a woman. In *Flight* the figures are shown running, with the man in back of the woman; the man holds the woman by the waist and raises his other hand up in a gesture, as Lipchitz himself said, "as though to protect himself and also protect the woman."[1]

In *The Road of Exile*, the pose has changed: the man carries the woman on his back. The depiction of the relationship between them has become much more emotionally charged. The dangers of flight from persecution are alluded to in the brooding atmosphere of the composition, where harm seems to lurk in the very shadows, its presence also embodied in the network of slashing black surrounding the figures like a threatening storm. The figures themselves seem heavy, perhaps near exhaustion, as an expression of the tremendous burdens endured on the road for the sake of survival.

In *Arrival*, Lipchitz returned to the running pose that he had employed in *Flight* and he adds the figure of a child who is held aloft by the woman. What *Arrival* shares with *The Road of Exile* is the intensity of feeling—here, of the joy of finding safety. The heightened emotion that is characteristic of a number of works of the 1940s, including *Rape of Europa*, *Theseus and Benediction*, can be seen as having its source in this powerful series of works.

The Road to Exile, for all the power of the specific circumstance it addresses, transcends the purely personal element and takes on a universal meaning.

R.C.

1. Jacques Lipchitz, *My Life in Sculpture* (New York: Viking Press, 1972) p. 141.

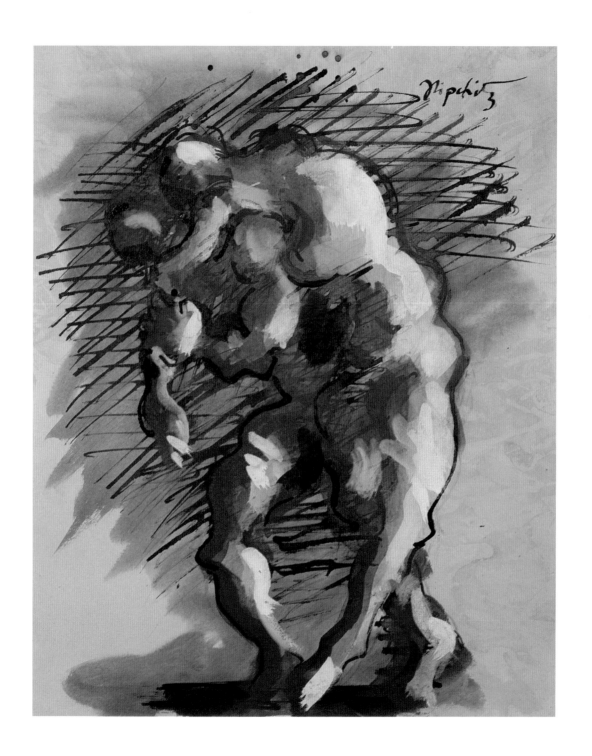

REGINALD MARSH (1898–1954)

47. *The Rex Passes the Battery*, 1939

Watercolor and gouache on paper
21¾ × 30 inches
Signed and dated lower right: *Marsh 1939*

PROVENANCE
Private Collection, New York

THE SON OF ARTISTS, Reginald Marsh was born in Paris. He studied art at Yale University before moving to New York, where he first designed theater sets and worked as a freelance illustrator, contributing drawings to such publications as the *New Yorker* and the *Daily News*. At the Art Students League in the early 1920s he attended an evening drawing class taught by John Sloan. He also studied with George Luks and Kenneth Hayes Miller, the latter proving the most decisive influence on his early career, inspiring his passion for the works of the Old Masters of the sixteenth and seventeenth centuries: Titian, Michelangelo, and especially, Rubens. A member of the 14th Street School which centered around Miller, Marsh associated also with Moses and Raphael Soyer, Isabel Bishop and other urban realists.

In his paintings, drawings, etchings and photographs Marsh captured the pulse and energy of New York from the 1920s through the 1950s. He concerned himself with what he called the "big picture of American life," of which he gives glimpses in his depictions of New York's crowded streets, the burlesque halls filled with commotion, the bread lines of the Depression era, and the mobs at Coney Island. His background as an illustrator had a significant impact on his style, which reflects also the documentary mode of 1930s photography.

In *The Rex Passes the Battery*, Marsh captures the robust spirit of New York City at the end of the 1930s. At a pier at the southern tip of Manhattan a crowd congregates. Buxom women in brightly colored, swaying skirts and high heels intermingle with the passing throng. Jostled by the wind, the crowd seems alive with movement and energy, while in the background the Rex, a gigantic steamer, bursts into view. The painting reverberates with echoes of the Baroque masters Marsh revered: one woman's hat is positioned halo-like on her head, while the full-bodied female figures suggest those of Rubens.

Typically for Marsh, the painting's action resides on the front plane. With its frieze-like composition, the scene seems to pass before the viewer's gaze like a frame in a movie. Acknowledging the flux of the modern world in his work, Marsh presented a cinematic vision of New York, capturing glimpses of the ever-changing urban spectacle.

The best interpreter of the nation's complex social fabric in the early decades of the century, Marsh also captured the era's *joie de vivre*. In depicting the New York experience—the new sensationalism, the popularization of the media and the clashing of cultures—Marsh created the most indelible record of urban life of any American artist of his time.

L.P.

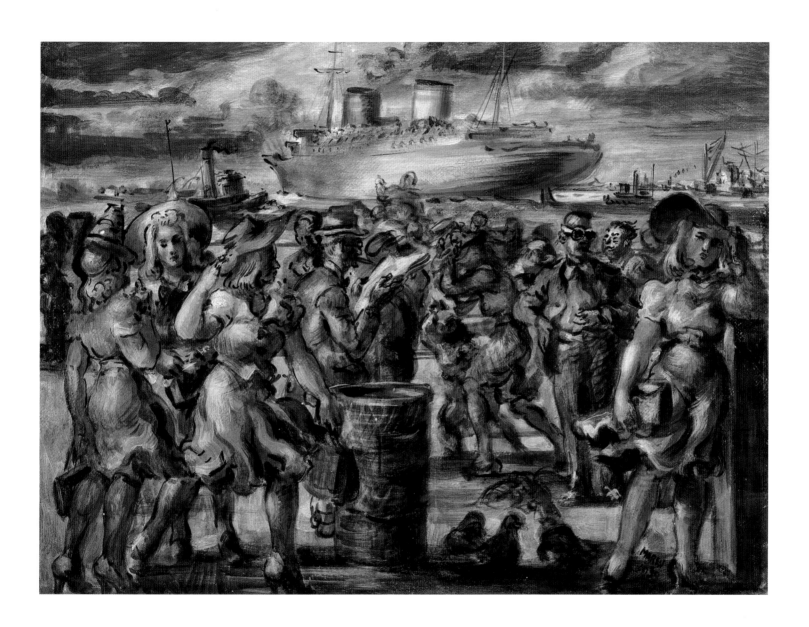

ARTHUR FRANK MATHEWS (1860–1945)

48. *Gathering in Monterey, California*, ca. 1913

Gouache on paper
23 × 21½ inches

PROVENANCE
Estate of Miller Parker, Merced, California

ARTHUR F. MATHEWS, the quintessential California artist, was a gifted painter and muralist, an influential teacher, a director (1890–1906) of the Mark Hopkins Institute of Art (San Francisco's premier art school) and the leader of the Arts and Crafts movement known as the California Decorative style.

Mathews introduced an entire generation of Californians to the modern European movements, from French Impressionism and Symbolism to the English Arts and Crafts movement, and then, through the powerful example of his own work, showed that American artists could match their European counterparts.

Gathering in Monterey, a gouache and pencil study on brown paper, appears to be related to a group of sketches now in the Santa Barbara Museum of Art. These sketches, in turn, are studies for the twelve-panel mural representing the history of California, that hangs in the State capitol building in Sacramento. A commission for the rotunda, the mural which was installed in 1914 was Mathews' most important public work. It shows him as the equal of Europe's greatest masters of historical allegory, including his favorite, Puvis de Chavannes, the French Symbolist to whom Mathews frequently has been compared. The mural remains a popular attraction and has long been regarded as one of the most successful public commissions in the United States.

The mural divides the history of California into four periods. *Gathering in Monterey* is a study related to the third panel of the second triptych, which is devoted to "The Mission Period And The Picturesqueness of the California Landscape." The third panel, according to the original description accompanying the mural, treats the event that signaled the end of the Mission period and Mexican rule in California: the entry into Monterey Bay of Commodore John Sloat of the U. S. Navy. Mathews' focus is on showing Commodore Sloat's arrival, and the awaiting citizens of Monterey who have gathered to watch "oblivious to the past for the official arrival of America in California."

In the study *Gathering in Monterey*, the main concerns are the setting and the onlookers. Working in quick strokes, particularly in the feathery treatment of the tall Monterey cypress and the bold tonal rendition of the sky, Mathews has given enchanting expression to his lifelong interest in conveying "the picturesqueness of the California landscape." In the lively sketches of the figures he depicts the range of types who would have been present and suggests an almost festive atmosphere of anticipation.

The traces of other figures, as well as what appears to have been a flag extending from the corner of the adobe-style building, are evidence of Mathews reworking, testing ideas.

R.C.

JAN MÜLLER (1922–1958)

49. *Riders in a Landscape*, ca. 1954–1958

Pastel on paper

10⅛ × 12⅜ inches

PROVENANCE
Private Collection, New York

BORN IN GERMANY, Jan Müller arrived in New York in 1941. He began to study painting with his famed countryman Hans Hofmann in 1945, at the Art Students League in New York. Müller's early painting reflected the abstract tendencies prevalent among Hofmann's students, but he turned to figurative painting in 1954, inspired by the German Expressionist painters of the early decades of the century. *Riders in a Landscape* reveals Müller's redefinition of Blue Rider images and forms through the vibrant color preferred by Hofmann.

Müller's pastel landscape well captures the spirit of the Blue Rider artists in its harmonious integration of figures, horses, and trees, to present an affirmative interpretation of the relationship between man and nature. Brilliant colors, applied in large patchy areas, and the lack of specific detail reveal Müller's attempt to capture the essences of the visual world. One of the founders of the Hansa Gallery, Müller exhibited there from 1954 until his death four years later, a period during which he was also associated with the Sun Gallery in Provincetown, Massachusetts, where his figurative works such as *Riders in a Landscape* exerted considerable influence.

P.N.

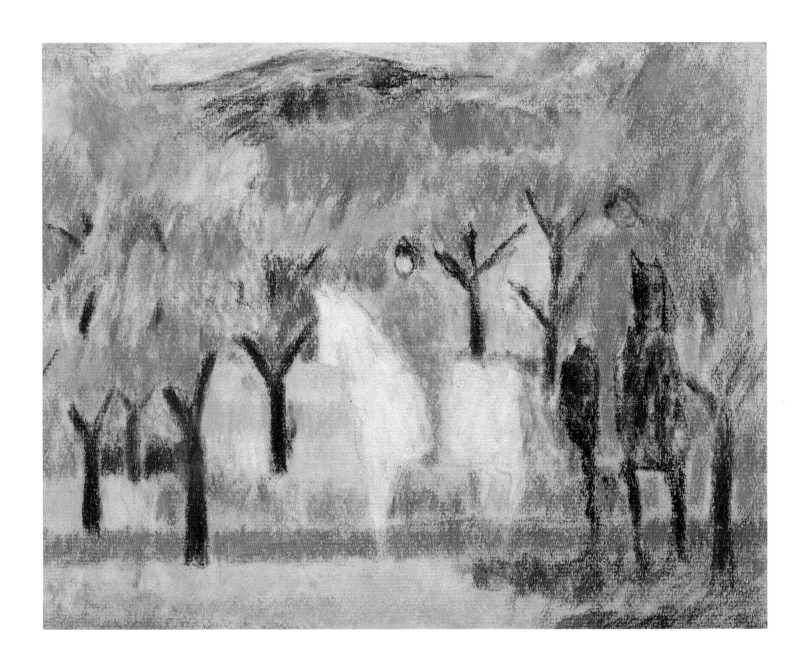

ELIE NADELMAN (1882–1946)

50. *Chanteuse (Standing Woman)*, ca. 1916–1919

Pencil on lined paper

8½ × 5¾ inches

PROVENANCE

Estate of the artist

[Rex Evans Gallery, Los Angeles]

Private Collection, West Coast, United States

RECOGNIZED AS ONE of the mainstream figures of modern sculpture, Elie Nadelman received his formal training at the Warsaw Art Academy, the city where he was born. After a brief sojourn in Munich during 1904, he settled in Paris.

Nadelman's earliest work, schematic and angular, has often been referred to as "quasi-cubist" and is thought to have influenced both Picasso and Brancusi. Focussing his attention particularly on the female form, he eventually developed an approach noted for its simplicity, idealization and the use of graceful arcs and curves. Throughout his career, Nadelman successfully integrated a diversity of stylistic traditions into his work, ranging from classical sculpture and primitive art to art nouveau and folk art. His early patrons included such collectors as Leo and Gertrude Stein and Helena Rubenstein.

After moving to New York City in 1914, Nadelman began carving polychromed figures in wood, inspired by his discovery of the American folk art tradition as well as his knowledge of dolls, mannequins, wooden toys and the art of Georges Seurat. His subjects, drawn from contemporary life, included society types, singers, dancers and circus performers.

Nadelman's *Chanteuse (Standing Woman)*, a profile of a woman standing with one arm poised demurely in front of her, is related in pose and costume to a wooden sculpture from the late teens entitled *Chanteuse*. Like its sculptural counterparts, *Chanteuse (Standing Woman)* superbly illustrates Nadelman's concern for the simplification and abstraction of form, achieved through the use of curved contours. Indeed, throughout his career Nadelman saw the curve as the underlying formal principle of his art. Writing in Alfred Stieglitz's *Camera Work* in 1910, he outlined his aesthetic:

But what is the true form of art? It is significant and abstract, i.e. composed of geometrical elements. Here is how I realize it. I employ no other line than the curve, which possesses freshness and force. I compose these curves so as to bring them in accord or in opposition to one another. In that way I obtain the life of form, i.e. harmony . . . The subject of any work is for me nothing but pretext for creating significant forms, relations of forms which create a new life that has nothing to do with life in nature . . .[1]

In her lack of facial features and anatomical detail, as well as in her acute stylization, *Chanteuse (Standing Woman)* reminds us of the similarly enigmatic figures of Seurat. However, despite her apparent anonymity, Nadelman endows this doll-like figure with an elegant lyricism that is all her own.

C.L.

1. Elie Nadelman, "Photo-Secession Notes", *Camera Work*, No. 32 (October 1910): 41.

JULES PASCIN (1885–1930)

51. *Sunday Morning in Charleston*, 1919

Watercolor, pen and ink on paper
11¼ × 10¾ inches
Signed, dated and inscribed lower left: *Pascin/Charleston 1919*

PROVENANCE
Violette de Mazia Collection, Pennsylvania

BORN IN A SMALL town in Bulgaria near the Romanian border, Jules Pascin revealed his artistic talents quite early. While still a teenager he was beginning to earn his way as an illustrator and painter in Munich and Paris. In 1914, fleeing the war, he left Paris for New York. He returned to France in 1920. A leading modernist in Paris, Pascin was welcomed in New York, and was soon teaching at the Art Students League. His style, with its harmonious assimilation of elements of Expressionism and Cubism within a figurative context, held much appeal for progressive American artists. Pascin offered a way of responding to advanced pictorial conceptions without embracing them for their own sake. Echoes of his style, especially his draftsmanship, with its subtle combination of linear and tonal treatments of form can be found in the work of American artists such as Peggy Bacon and Yasuo Kuniyoshi.

Sunday Morning in Charleston belongs to a group of drawings Pascin made while on a trip through the South in 1919. An inveterate traveller, Pascin used drawing to record his impressions of the new people and places he encountered. In this watercolor, Pascin has provided a captivating portrayal of a group of women and girls on a veranda. In Cubist fashion he has opened up the structure of the veranda to create a lyrical, atmospheric but still ambiguous space in which elements of the indoors and outdoors (the colorful expanse of the South Carolina landscape) have been brought together. The figures seem to be very much at ease in this setting of gentle upheaval, where straight lines and right angles have been banished. No doubt this place was their home, given the easy intimacy between them that is conveyed through pose and gesture; from the repeated rhythms and contours of their bodies, they seem to be members of the same family. Pascin's powers were at their pinnacle when treating female subjects, and with the engaging characterizations of *Sunday Morning in Charleston* he has given us a particularly graceful meditation on womanhood and humanity.

R.C.

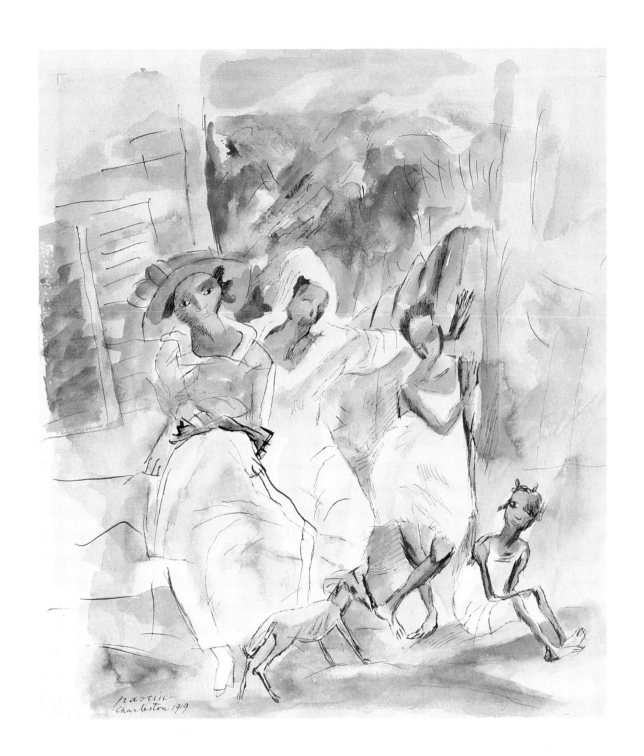

EDGAR PAYNE (1882–1947)

52. *A Day's Preparation*, ca. 1922–1924

Watercolor and conte crayon on paper
14⅛ × 14¼ inches
Signed lower right: *Edgar Payne*
Inscribed on backing, removed: *A Day's Preparation*

PROVENANCE
Private Collection, California

AT THE AGE OF FOURTEEN, Edgar Payne left his home in Washburn, Missouri, to visit the South, the Midwest and Mexico, setting a pattern of wanderlust and travel that consumed him throughout his life. Although he studied briefly at the Art Institute of Chicago, Payne was essentially self-taught. In 1917, he established his residency in Laguna Beach, California, where he became active in the local art community and helped found the Laguna Beach Art Association in 1918. Most well known for his paintings of the Sierra Nevada, which he rendered with a sensitivity to decorative effects and striking color arrangements, Payne also created vivid depictions of sites in California, Arizona, New Mexico, Canada and Europe.

Small in number relative to his American works, Payne's European images, created during his 1922–1924 trip abroad, are his most experimental. *A Day's Preparation*, sketched in conte and overlaid with watercolor, exemplifies the exploratory approach he took. Depicting an Italian harbor (possibly that of Chioggia, an island near Venice that Payne visited), the work captures the effects of early morning light on a quiet bay. Sails attracting the pink glow of dawn cast shimmering shadows in a rich turquoise basin. Set at oblique angles, boats and sails present a decorative web of colors and overlapped planar shapes. The work's square format orders and contains the vivid, animated arrangement. While delineating the scene realistically, Payne creates a sparkling mosaic of color and pattern, demonstrating his awareness of abstract principles of design.

L.P.

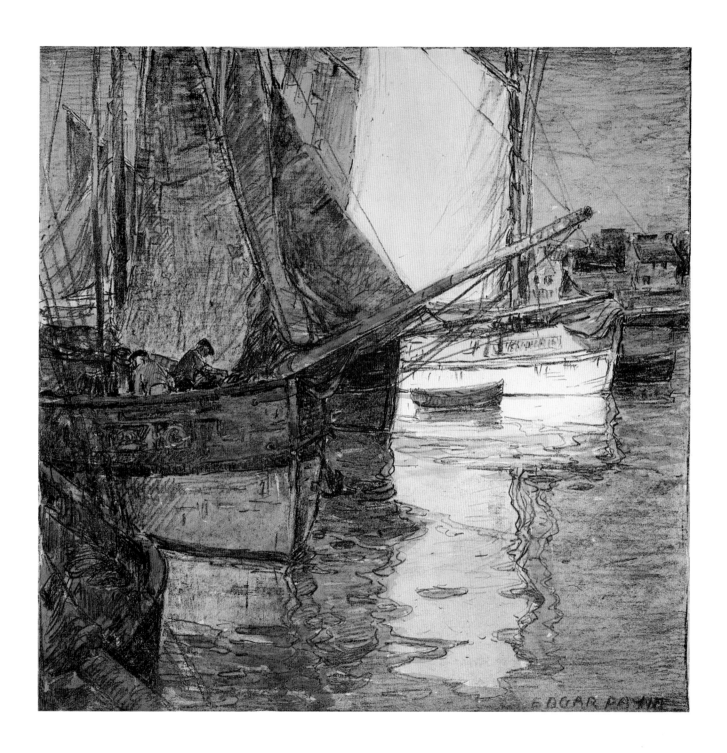

AGNES PELTON (1881–1961)

53. *Harvest Bounty*, ca. 1900–1910s

Pastel on paper
9 × 12¾ inches
Signed lower left: *Agnes Pelton*

PROVENANCE
Private Collection, California

A PAINTER OF LANDSCAPES, portraits and floral subjects, Agnes Pelton was one of the few woman artists invited to participate in the 1913 Armory Show. Although she initially worked in a representational manner informed by the tenets of Impressionism and Post-Impressionism, Pelton later became a pioneering figure in the development of American abstraction. Inspired by a diversity of sources that included Cubism, Surrealism and the art of Wassily Kandinsky, Pelton abandoned figuration during the mid–1920s, and began exploring the emotional and spiritual effects of color. In 1938, along with such artists as Emil Bisttram and Raymond Jonson, she helped found the Transcendental Painting Group in Santa Fe, New Mexico. Their main aesthetic precepts, involving the creation of forms that were "cosmic, universal and timeless," guided Pelton's art through the rest of her career.

While she is best known today for her work as an abstractionist, Pelton was also an accomplished landscape painter. Shortly after her graduation from the Pratt Institute in Brooklyn in 1900, she attended outdoor painting classes given by William L. Lathrop in Old Lyme, Connecticut, in which she studied the effects of natural sunlight on the landscape. Many of her early works, executed in New England and on Long Island, where she kept a studio in the Hay Ground Windmill, reveal a developing interest in light and color.

Like other American artists influenced by *pleinair* painting and Impressionism, Pelton frequently worked in pastel. As an affirmed colorist, she would certainly have found the medium's brilliant palette appealing. In *Harvest Bounty*, Pelton has portrayed several clusters of wheat sheaves in a grassy meadow. While each individual bundle has been depicted with quick, directional strokes of chalk—in yellow ochre, dark brown and lighter buff tones—the surrounding countryside and sky has been rendered with the broad side of the chalk, creating soft masses of color and form. Pelton also adds volume and substance to the various elements by allowing portions of the tan paper to emerge, notably in the foreground area and in the wheat sheaves themselves. *Harvest Bounty*, in its fresh chromaticism as well as in its directness and spontaneity, well exemplifies Pelton's early success at rendering the "radiance of light" through color.

C.L.

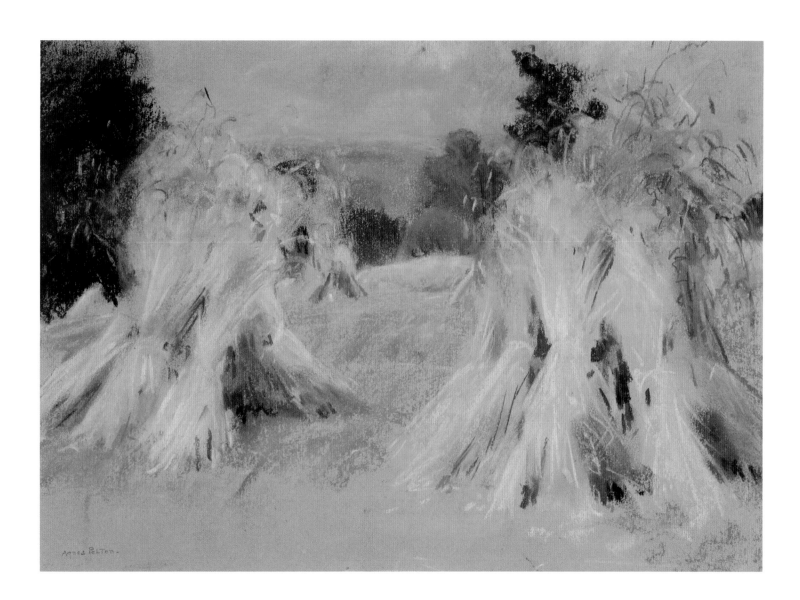

JOSEPH PENNELL (1860–1926)
54. *Busy Day in the Bay*, ca. 1921–1926
Watercolor and gouache on paper
7 × 9⅔ inches
Signed upper left: *Jo Pennell* (JoP in monogram)
Inscribed in pencil, verso, upper left: *Busy Day*

PROVENANCE
[Associated American Artists, New York]
Private Collection

JOSEPH PENNELL thought of New York as the dynamic city of the future, full of continual rebuilding and new growth, both within its cavernous metropolis and busy harbors. He observed the city's progress each time he returned to the States (en route to his native Philadelphia) during his long expatriate career—in 1891, 1893, 1904, 1908, 1915 and finally in 1918 when he settled permanently in Brooklyn Heights.

The bay traffic in New York was described in 1909 by John Van Dyke in his *The New New York*, one of the many books illustrated by Pennell:

> . . . the volume of New York's foreign trade . . . is five or six times as large as that of any other American city, and amounts to nearly one-half of the whole foreign trade of the United States. Each year over three thousand steamers and a thousand or more sailing vessels come up the bay from foreign ports.[1]

In Pennell's watercolor, *Busy Day in the Bay*, the artist documents the urban energy that he witnessed daily from his apartment high up in the twelve-story Hotel Margaret in Columbus Heights, Brooklyn.[2] He portrays the pluralistic river traffic of lower Manhattan like an elaborate board game in which tugs, fireboats, passenger steam ships and barges all ply the churning waves of the balmy waters surrounding the Statue of Liberty.

Pennell uses the watercolor medium in its loosest form, applying wet strokes of red-orange and gray-blue with touches of gouache to outline the varying structures of the ships. The Statue of Liberty, which the artist once described as "far more dignified than the legendary Colossus of Rhodes,"[3] is shrouded in mist, as are the lightly outlined buildings of the Battery seen against a softly glowing sky.

Busy Day in the Bay reminds us that Joseph Pennell was one of the first to realize that the city of the early twentieth century offered a subject that not only embodied the modern era but one that could also be appreciated for its sheer, picturesque beauty.

L.B.

1. John C. Van Dyke, *The New New York* (New York: Macmillan Company, 1909), p. 87.
2. A series of watercolors executed from Pennell's "bird's eye" view of the New York harbor were published as etchings in 1926 as *The Great New York* (Boston: LeRoy Phillips).
3. Joseph Pennell, *Pennell's New York Etchings* (New York: Dover Publications, 1980), p. xiv.

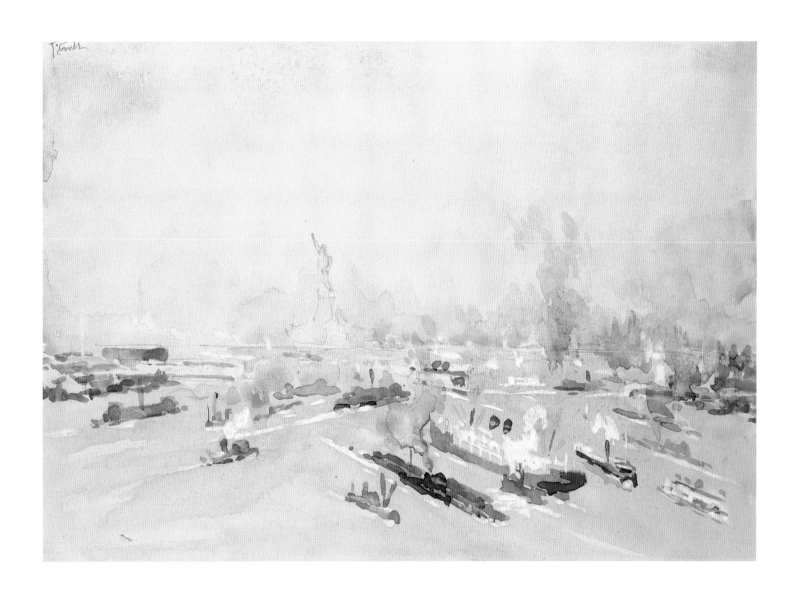

FAIRFIELD PORTER (1907–1975)

55. *The Wall*, ca. 1974

Watercolor on paper
9 × 12 inches
Inscribed lower right: *Fairfield Porter/ASP*

PROVENANCE
Estate of the artist
[Hirschl and Adler Galleries, New York]
Private Collection, Pennsylvania

EXHIBITED
Parrish Art Museum, Southampton, New York, *Fairfield Porter's Maine*,
 2 July–11 September 1977, cat. no. 31.

especially in the foreground landscape and the sky, allows light from the surface of the paper to show through, heightening the overall sense of luminosity and vitality.

Despite the near abstraction of his elementary forms, Porter's concern for realism and traditional structure are readily apparent. In this respect, as well as in his strong belief in the expressive qualities of watercolor and its ability to render the clarity and brilliance of Northeastern light, Porter carries on the American realist tradition represented by Winslow Homer and Edward Hopper.

C.L.

FAIRFIELD PORTER, an important American realist, was renowned for his colorful, evocative landscapes and his intimate, sunlit interiors. Educated at Harvard University and at the Art Students League in New York, Porter was also a respected art historian. His articles and critical reviews appeared in *Art News*, *Art in America* and *The Nation*. He also wrote a monograph on another American realist, Thomas Eakins (1959).

While Fairfield Porter worked in watercolor at various times throughout his career, he used the medium with increasing frequency during the last decade of his life. He was particularly fond of its ability to render the spontaneous effects of sunlight and shadow. Although he produced a few figure studies, his work in watercolor tended to be landscapes, painted in and around Southampton, Long Island, and in Great Spruce Head, Maine.

Influenced by the "intimism" of Vuillard and the Nabis, Porter usually painted subjects which were familiar to him. Thus, although the exact locale of the view depicted in *The Wall* is not known, this work probably depicts an often-encountered spot on Long Island or in Maine. Indeed, we can almost picture the artist standing before the dense barrier of tree-covered terrain that confronts him. Such close-up views of nature are typical of Porter's late work. So too, is the simplified composition, where forms, enveloped in an all-pervasive light, are broken down into three distinct areas—meadow, trees and sky—which have been rendered in broad washes of fresh blues and greens. The transparency of the paint,

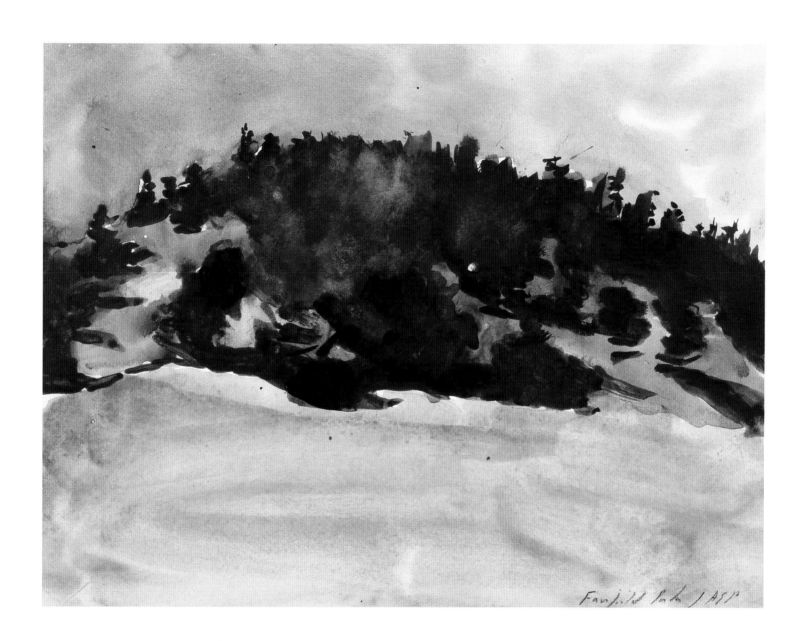

Fairfield Lake / 85

WILLIAM T. RANNEY (1813–1857)

56. *Washington and Gist Crossing the Allegheny River*, ca. 1854

Watercolor and pen and sepia ink on paper
10¾ × 14¾ inches

PROVENANCE
Estate of the artist
[Ranney Fund Sale, National Academy of Design, New York, 21
 December 1858, possibly no. 89, and incorrectly entitled *Study for
 Picture, Washington Crossing the Susquehannah*, sold to Wood]
Private Collection, New York State

NOTE
This work is a study for *Washington and Gist Crossing the Allegheny River*
(1854, oil on canvas, 39 × 55 inches, Collection of The Richard
King Mellon Foundation, Pittsburgh, Pennsylvania). See Francis
S. Grubar, *William Ranney, Painter of the Early West* (New York:
Clarkson N. Potter, Inc., 1962), pp. 44, 58.

WILLIAM RANNEY was one of the most important American
genre painters of the mid-century, noted especially for his
renderings of subjects from American history, and Western
and sporting scenes. Born in Middletown, Connecticut, in 1813, he was
apprenticed to a tinsmith in Fayetteville, North Carolina, but by 1833 he
was diligently pursuing his art studies in Brooklyn, New York. Three
years later, he enlisted with the Army of the Republic of Texas and
witnessed the struggle for independence from Mexico, an experience that
left a lasting impression, culminating in his important Western paintings
of a decade later.

In 1843, Ranney established a studio in New York City, where his
reputation soared and where he received regular commissions from the
American Art Union. He settled permanently in West Hoboken, New
Jersey, in 1853, after which he produced a number of portraits and history
paintings dealing with the Revolutionary War, and Western genre subjects
depicting the daily lives of trappers and hunters.

One of the historical subjects of this period was a series depicting
George Washington's 1753 military assignment to deliver a warning to the
French who were encroaching on the waters of the Ohio valley. Ranney's
research of this event resulted in such masterpieces as *Washington's
Mission* (ca. 1847; oil on canvas; location unknown) and *Washington and

Gist Crossing the Allegheny River (1854; oil on canvas; Collection of the
Richard King Mellon Foundation, Pittsburgh).

A wash drawing for the latter depicts the young Washington, in the
official uniform of the Virginia militia, astride a make-shift raft with his
guide for the expedition, Christopher Gist. Gist's diary for Saturday,
November 29th, describes the perils of the trip:

> We set out early, got to Allegany, made a raft, and with much difficulty
> got over to an island, a little above Shannopin's town [Pittsburgh]. The
> Major having fallen in from off the raft, and my fingers frostbitten, and
> the sun down, and very cold, we contented ourselves to encamp upon
> that island. It was deep water between us and the shore; but the cold did
> us some service, for in the morning it was frozen hard enough for us to
> pass over on the ice . . .[1]

Responding to mid-century demands for "genrefied" rather than
idealized treatment of historical subjects, Ranney skillfully re-creates, in
Washington and Gist Crossing the Allegheny River, the specific details of
costume and atmospheric conditions of an event of one hundred years
earlier as though it were happening in his own time.

L.B.

1. William M. Darlington, *Christopher Gist's Journals*, (Pittsburgh, 1893), quoted in
Francis S. Grubar, *William Ranney: Painter of the Early West* (New York: Clarkson
N. Potter, 1962) In a letter to Spanierman Gallery of 13 August 1989, Professor
Grubar states that "this is a more detailed study than others I have seen for this
subject."

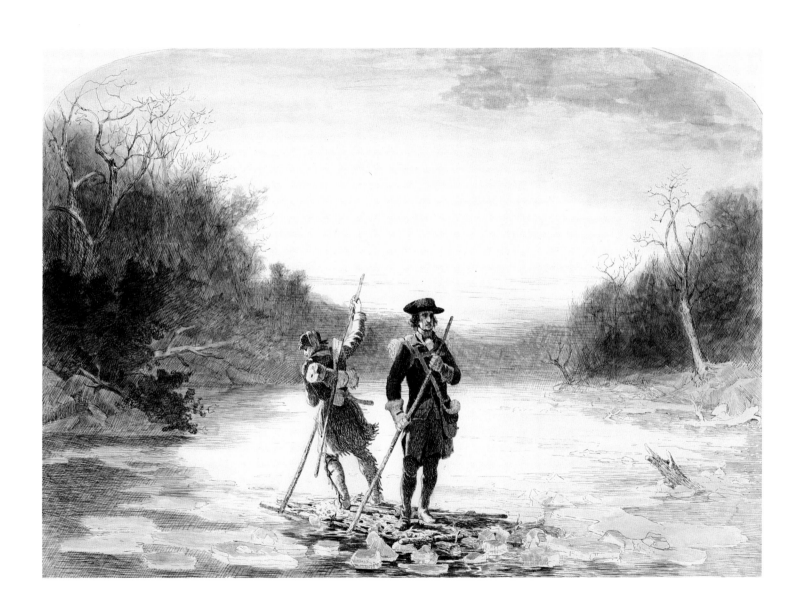

JOSEPH RAPHAEL (1872–1950)

57. *The Passing Band, Marché St. Caterien, France*, ca. 1920s

Pencil, chalk, brush and ink with gouache on paper laid on paper
19½ × 26½ inches
Signed and inscribed lower right: *The Passing Band Marché St. Caterien /
 Jos Raphael*

PROVENANCE
Private Collection, London, England

ALTHOUGH HIS MATURE career was mostly spent abroad, Joseph Raphael maintained close ties to his native northern California and is considered one of the most original of the state's Impressionists. Born in Jackson, California, Raphael studied at the Mark Hopkins Institute of the San Francisco Art Association under Arthur Mathews and Douglas Tilden and then, beginning in 1903, at both the École des Beaux Arts and the Académie Julian in Paris.

Raphael soon began to divide his time between Paris and the artists' colony of Laren, Holland, where he concentrated on dark figural studies in the manner of the Hague School. In 1910 he returned for eight months to San Francisco, his reputation having been assured by his previous submissions to the San Francisco Art Association annuals. By this time, his style had evolved into a unique blend of Impressionist subjects— florals and figures within garden environments— and dynamic Expressionist brushwork.

By 1912 Raphael and his family were living at Uccle, a suburb of Brussels. In the ensuing war years, materials were scarce and he turned to watercolor, woodblock prints and pen and ink work. His *The Passing Band*, a drawing depicting the busy market square of Saint Caterien, Paris, is probably of the period.

A wild array of figures, market stalls and bountiful baskets of produce fill the picture space. Two women in the foreground link arms in an impromptu dance, urged on by a circle of gesticulating local characters. Given the vigorous linework and pointillist daubs of ink throughout, one can easily miss "the passing band," an orderly procession of top-hatted figures who march along the periphery of the square. As their rows thin out toward the end however, their ranks appear in slight disarray as several of the band members turn to gaze at the more interesting activity of the market people, who in turn seem oblivious to their officialdom.

The Passing Band is not only an excellent example of Joseph Raphael's technical virtuosity, but it brings to life the rich and often complex social structure that existed within Parisian society of the 1920s.

L.B.

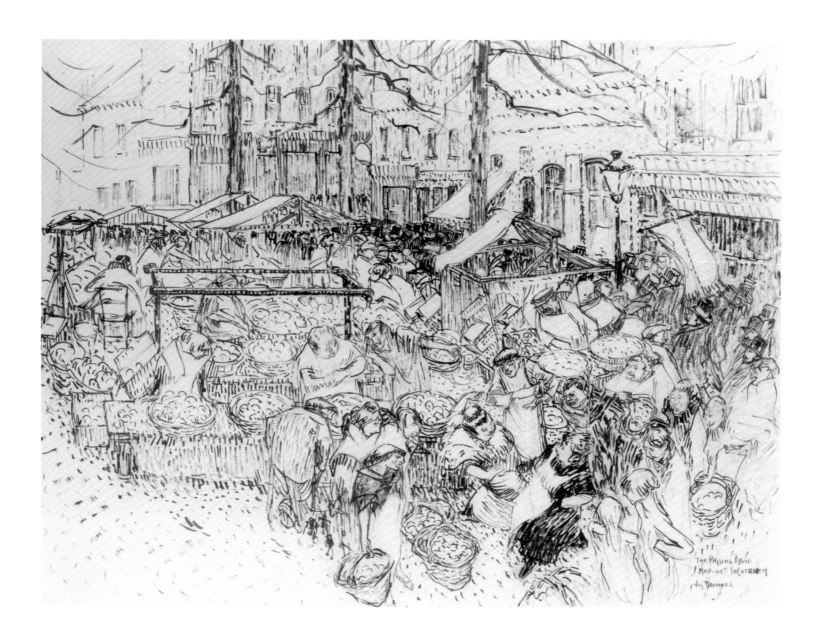

THE PASSING DAYS
MARCHÉ Ste CATHERINE
Jos. Raphael

WILLIAM TROST RICHARDS (1833–1905)

58. *The Wave*, ca. 1880s–1890s

Gouache on grey paper

4½ × 9⅝ inches

PROVENANCE

Estate of the artist

American Academy of Arts and Letters, New York

Educational Institution, New York State

Private Collection, Washington, DC

WILLIAM TROST RICHARDS was a specialist in landscape and marine subjects. During the 1850s, while working as an illustrator and designer of ornamental metalwork in his native Philadelphia, he studied painting and drawing under the German-born artist Paul Weber. Richards' early landscapes, informed by the descriptive realism of the Hudson River School, consisted of tightly rendered and topographically accurate views of the Catskill and Adirondack mountains.

After viewing an exhibition of British art in Philadelphia in 1858, where he was exposed to the work of the Pre-Raphaelites, Richards began to focus his attention on meticulous, scientifically exact renderings of woodland interiors and botanical subjects. Inspired by the aesthetic theories of John Ruskin, Richards' literal treatment of nature soon led to his identification with the American Pre-Raphaelites and his election, in 1863, to the Association for the Advancement of Truth in Art.

During the early 1870s, after spending several summers on the Atlantic seaboard, Richards turned his attention to seascapes. He was particularly intrigued by the movement of water, or in his own words, the "magnificent action of the sea." Richards also began to paint extensively in watercolor. By 1873, one year before he became a member of the American Society of Painters in Water Colors, he was being heralded as among the "best-known watercolor painters of America."[1] Richards' watercolors were enthusiastically collected by the Reverend Elias Magoon and George Whitney, among many others.

In 1875 Richards purchased a house in Newport, Rhode Island. He summered there until 1890, when he became a year-round resident. During these years, as he developed a familiarity with the tenets of Impressionism and *plein air* painting, Richards broadened his earlier, precise painting style, taking a greater interest in light and atmosphere, and a more subjective approach to nature. His new manner is evident in the numerous landscapes and seascapes of Rhode Island and in the various seascapes painted during the seven trips he made to Europe between 1891 and 1903. Exploring the coasts of England, Scotland and Ireland, Richards endeavored to record the "many shores where I think no other painter has been."[2]

In *The Wave*, a restless nocturnal surf breaks on a deserted beach. The work reflects Richards' penchant for lonely, isolated coastal areas as well as his concern for light and atmosphere. Although the moon is not visible, its glowing light emanates from both the water and the shore. Subtle modulations of dark blues and greys are highlighted by touches of white and lighter buff tones, all applied with a loose, painterly brushstroke. Certainly, small-scale works such as *The Wave*, not intended for formal exhibition, were for Richards personal expressions of his response to nature. Thus, as well as reflecting Richards' interest in the effects of light and the motion of water, *The Wave* also reveals the lyricism inspired in him by the sea.

C.L.

1. "Art: The Exhibition of Water Colors." *Aldine* 6 (April 1873): 87.

2. William Trost Richards to William Macbeth, 10 April 1892, quoted in Linda S. Ferber, *William Trost Richards: American Landscape and Marine Painter*, exh. cat. (Brooklyn: Brooklyn Museum, 1973), p. 36.

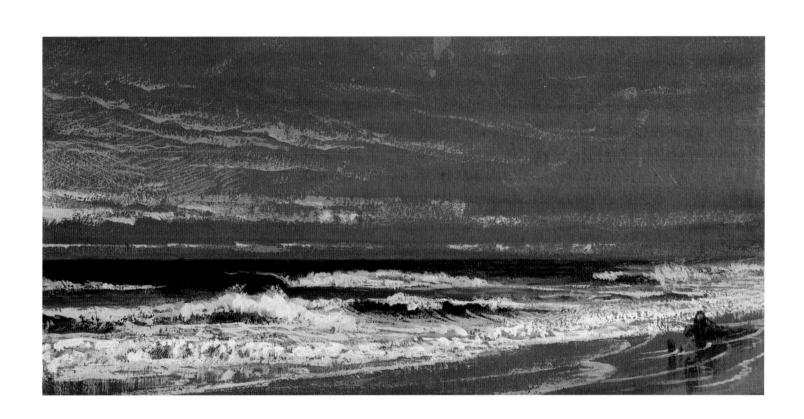

THEODORE ROBINSON (1852–1896)

59. *Woman at a Hearth*, ca. late 1870s

Ink on paper laid down on paper
14½ × 13 inches
Inscribed lower left: *Normandy Interior/Theo. Robinson*

PROVENANCE
Private Collection, New York State

Woman at a Hearth represents Robinson's skills as a draftsman as well as his proclivity for themes of rural life. In this drawing, probably executed during Robinson's first trip to France, he presents us with a young peasant woman seated before a cast iron stove. The composition is delicately but solidly drawn, illustrating Robinson's concern for volume and form. In this respect, *Woman at a Hearth* reflects the influence of Robinson's academic training as well as the realism that characterized his *oeuvre* throughout his brief but influential career.

C.L.

A SPECIALIST IN LANDSCAPES and figural themes, Theodore Robinson was renowned for his personal adaptation of Impressionist strategies to American subjects. Robinson was also an important member of the first generation American Givernois and one of the few artists to be admitted into the inner circle of Claude Monet.

Robinson was born in Vermont and raised in Wisconsin. He began his formal training at the Art Institute of Chicago in 1869. However, recurring bouts of asthma, which plagued him throughout his life, necessitated his return to Wisconsin the following year. Robinson later moved to New York, resuming his studies at the National Academy of Design.

In 1876 Robinson went to Paris, enrolling in the *atelier* of Auguste-Émile Carolus-Duran. He also worked under the distinguished academician Jean-Léon Gérôme, whose emphasis on such traditional academic precepts as solid draftsmanship and sound composition remained an integral part of Robinson's art even after his conversion to Impressionism in the late 1880s. During his student years, Robinson made frequent sketching trips throughout Normandy. He also visited the art colony at Grez, near Fontainebleau, fraternizing with fellow Americans such as Birge and Alexander Harrison and Will Hicok Low.

Robinson returned to New York in 1879. In the ensuing years, he taught and worked on various decorative projects with John LaFarge. He returned to France in 1884, spending the first of several summers at Barbizon, where he familiarized himself with the peasant imagery of Jean-François Millet. He made his first trip to Giverny in 1887, acquiring a house next door to Monet the following year. Robinson continued to spend his summers in Giverny until his permanent return to America in 1892. He spent the remaining years of his life applying his Impressionist manner to native subjects.

ALEXANDER SHILLING (1859–1937)

60. *Edge of the Forest*, before 1914

Oil pastel on tinted paper
12½ × 19¼ inches
Signed lower left: *Alexander Schilling*

PROVENANCE
Estate of the Artist
Dr. William Dunning (friend and executor of the artist)
The children of William Dunning

ALEXANDER SHILLING was a landscape painter and printmaker who specialized in moonlit scenes of Holland, Belgium, Quebec, New Jersey and the Adirondacks. He was born in Chicago in 1859 and at eighteen was apprenticed to Henry A. Elkins, a local painter. In 1878 he opened his own studio at the same time he was enrolled at the Chicago Academy of Design, where his associates were Arthur B. Davies, John Vanderpoel, Albert Sterner and the sculptor George Gray Barnard. He taught at the Academy in the early 1880s while also conducting private classes in his studio.

Shilling's early work was mostly in printmaking and one of the first organizations he joined when he moved to New York City in 1885 was the New York Etching Club. Later, he was a member of the American Watercolor Society, the Salmagundi Club and the Century Club, all in New York.

After his first trip to Europe in 1888, Shilling began to work in oils, and by the 1890s he had developed his characteristic subjects, mostly rural nighttime scenes. His mature work was influenced by the French Barbizons and the art of his friends, Albert Pinkham Ryder and Horatio Walker, the latter a Canadian artist whom Shilling often visited in Quebec. The artist also frequented the Adirondacks and, in later years, the area near Twin Lakes, Connecticut. In Europe, he often sketched in Veere, Holland and after World War I, in Bruges, Belgium.

Shilling's *Edge of the Forest*, an oil pastel on toned board, offers a good example of the artist's technical skills. We can assume the work to have been executed prior to World War I, since it is signed, *Schilling,* the family name before he anglicized it to *Shilling.* The pastel gives us few clues as to locale. Barbizon-like in its massing of foliaged areas silhouetted against an opalescent sky, *Edge of the Forest* also draws from American sources, such as the work of Dwight Tryon, George Inness, Ryder and Walker.

Shilling's concern for subtle gradations of tone in oil is also obvious in pastel. *Edge of the Forest* displays a palette of cool tones in its overlapping land elements, each treated with different textures— horizontal and broad strokes of the crayon for the sky and foreground and diagonal touches in the greenery.

Shilling's handling of trees received special attention from his critics. Wrote one reviewer:

> He loved trees and was always painting them. They are primarily interesting for the skillful manner in which he defines tree forms and then for the beauty in which, as though involuntarily, he envelops them. He could not have erected his delicate fabrics of design if he had not first mastered the structural truths on which they were bound to rest.[1]

Truly a "delicate fabric of design," *Edge of the Forest*, with its aura of quiet poetry, reflects Alexander Shilling's special knowledge and appreciation of nature's subtleties.

L.B.

1. "The Work of Alexander Shilling," *New York Herald Tribune,* (undated clipping, Shilling File, Library, Museum of Modern Art, New York).

Alexander Schilling —

FRANCIS HOPKINSON SMITH (1838–1915)

61. *Along the Riva, Venice*, ca. 1900–1910

Watercolor, charcoal and gouache on paper
14½ × 24½ inches
Signed lower right: *F. Hopkinson Smith*

PROVENANCE
Private Collection, Connecticut

BORN IN BALTIMORE, Francis Hopkinson Smith began his career as a mechanical engineer. He was also a successful writer, the author of twelve novels and numerous magazine articles, many of which reported of his travels. Much of Smith's career was spent abroad and his sojourns in Europe, Turkey and Mexico provided the subject matter for his art. Yet Smith also maintained his ties with American colleagues throughout his career, participating avidly in the Tile Club and the American Watercolor Society, and a number of other organizations. Self-taught as an artist, he focused on watercolor and was a strong advocate of outdoor painting.

Smith's fascination with Venice lasted throughout his career. Over the course of three decades he spent almost every summer in the city. He described its sites and pleasures in his book *Gondola Days* (first published in 1897), and rendered its picturesque imagery in paintings and drawings. Smith painted his Venetian watercolors *en plein air*, capturing with a spontaneous vigor the crisp patterns and broad contrasts provided by the architecture and waterways of the city.

In *Along the Riva*, Smith depicts the wide sweep of the Riva degli Schiavoni, the main avenue of Venice as it juts out at the southern end of the island. In the distance are visible the double domes of the seventeenth century Baroque church, Santa Maria della Salute. The painting expresses the quiet leisure of a Venetian afternoon. Figures pause and chat while others stroll slowly. The gentle color arrangement contributes to the feeling of calm and ease.

Using a tinted paper, Smith allows the soft beige tone to establish the color of the sky. White gouache evenly applied distinguishes the walkway and buildings, and conveys the effect of strong light upon them. The strong and ordered composition expresses the harmony and delight the artist received from this scene. *Along the Riva* conveys the life of genteel pleasure that Smith enjoyed in Venice.

L.P.

WILLIAM LOUIS SONNTAG, JR. (1869–1898)

62. *Country Hillside*, ca. 1890s

Watercolor and gouache on paper
14 × 21 inches
Signed lower left: *Sonntag Jr.*
Inscribed verso upper left: *A Country Hillside*

PROVENANCE
Private Collection, New York State

WILLIAM L. SONNTAG, JR., the son of the noted Hudson River School painter William L. Sonntag (1822–1900), was widely admired for his skills as a draftsman, especially his ability to sketch quickly and accurately in outdoor settings. An active and influential participant in New York art life during the late 1880s and 1890s, Sonntag was an accomplished illustrator, and his truthful depictions of life in New York City, (as well as his thinking on life and art) were an important source of inspiration for the author Theodore Dreiser. Sonntag was also an amateur inventor and a lifelong student of mechanics, an interest given artistic expression in his deftly rendered portrayals of ships, trains and machinery.

A specialist in watercolor painting, Sonntag was known for his delicate, *plein air* landscapes of upstate New York and New England. *Country Hillside* exemplifies Sonntag's penchant for detail and his ability to render outdoor light. The central focus of the composition is a gently winding roadway that leads our eye up, past a slow moving stream, to the crest of an unidentified mountain. Two wood-frame buildings are situated directly to the left of the road. Beyond this, to the left, we are presented with a panoramic view of the distant landscape, including a meandering waterway.

Although Sonntag displays a concern for accuracy and detail, especially in the rendering of the architectural forms, the overall handling is subdued. Sonntag's fine, unlabored brushwork, combined with a palette dominated by fresh tones of green and blue, serves to unify the composition and to convey an atmospheric immediacy. It was just this type of approach that led to Sonntag's election to membership in the American Water Color Society in 1898.

C.L.

THEODOROS STAMOS (B. 1922)

63. *Infinity Field, Lefkada Series*, 1980–1981

Acrylic on paper

30¼ × 22¼ inches

Signed, dated and inscribed in pencil, verso, upper center: *"Infinity Field, Lefkada Series"* / *1980–1/Stamos*

PROVENANCE

Private Collection, Europe

THEODOROS STAMOS is the youngest of the first generation Abstract Expressionists, the elite group of American artists that includes Jackson Pollock, Barnett Newman, Mark Rothko and Robert Motherwell. From his first one-man show in 1943, given him at the age of twenty by Betty Parsons, the New York art dealer legendary for her discovery of talent, Stamos has continued to impress the art world with the passion and originality of his vision. A constant in his work has been the idea that nature should play a formative role in the creation of abstract art.

Infinity Field, Lefkada Series, begun in 1970, is one of Stamos' most important bodies of work. The series, named for a Greek island in the Aegean that has become a second home to the artist, demonstrates his mastery of the acrylic medium, his sophistication as a colorist and his use of nature as a continuing source of inspiration. The acrylics on paper, as shown by this example, are independent creations every bit as representative of the artist's aims as the works on canvas. Stamos' talent for conveying nature, in what might be termed her universal aspects, can be appreciated in this dynamic composition showing the vertical format with a tripartite division that has become a trademark of the series. If the heat of a summer's day is conveyed by the fiery reds that warm up the surface, and sheets of rock are suggested by layers of pigment, then the movement of clouds and sea is evoked by the irregular contours of the forms. In *Infinity Field, Lefkada Series*, Stamos reveals the field of abstraction to be an ideal meeting ground for art and nature.

R.C.

HENRY L. STEPHENS (1824–1882)

64. *Child Eating Ice Cream*, 1860

Watercolor and pen and sepia ink on paper
10½ × 8¼ inches
Signed and dated lower right: *Henry L. Stephens /15/1860*

PROVENANCE
Private Collection, Massachusetts

WATERCOLORIST AND ILLUSTRATOR Henry Louis Stephens was born in Philadelphia. After moving to New York in the late 1850s he worked for *Frank Leslie's Magazine* and *Harper's Weekly.* He exhibited with the American Society of Painters in Watercolors during the 1870s.

Child Eating Ice Cream is a charming rendition of the street-urchin subject increasingly evident in American art of the latter half of the nineteenth century. As in the works of John George Brown and others, the painting presents a humorous and obliging anecdote. Resting at his leisure, a pleased boy is absorbed in consuming his glass of ice cream, oblivious to the envy of his fellow bootblack, who searches for change in order to buy his own. The vendor, standing under a patched umbrella, casts a sly glance at her satisfied customer, aware that he may draw others to her stand. Rendering the work in a caricatural style suggestive of William Hogarth, Stephens parodies the situation, thus minimizing the dire social issues implicit in the subject. His pigment is deftly applied; objects and clothing are presented with a delight in telling details.

L.P.

ARTHUR SZYK (1894–1951)

65. *Pacte de la Société des Nations*, 1931

Watercolor, gouache, pen and ink and gold illumination over pencil on
 paper
14 × 10½ inches
Signed and dated lower right: *Arthur Szyk. Paris. 1931.*

PROVENANCE
Private Collection

POLISH BORN ARTHUR SZYK studied at the Academy of Fine
Arts in Krakow, Poland and then at the École des Beaux-Arts in
Paris. He became fascinated with manuscript illumination,
employing elaborate drolleries and minute detail in his commissioned
illustrations of biblical and classical texts, such as the *Song of Songs*
(1917), *Rubaiyat* (1939) and *Temptation of St. Anthony* (1924). Szyk was
keenly aware of the political tensions and atrocities occurring in Europe
before World War II, and he frequently commented on them in his
illustrations. Prior to the outbreak of the war Szyk moved to the United
States, settling first in New York City and then residing for the remainder
of his life in New Canaan, Connecticut.

In his watercolor *Pacte de la Société des Nations*, Szyk abandons
twentieth century techniques to return to the illuminated manuscript,
perhaps as a way of suggesting that civilization had not progressed since
the medieval period. The attention to detail in this watercolor, its
extravagant, decorated initial letter, its amusing and frightening margin-
alia, and the integration of image and text reveal Szyk's debt to his
medieval source. The universal theme of death is given a modern
interpretation, and the title suggests the collusion of nations in a
destructive pact. In the lower right margin the specter of death appears as
a modern soldier who gestures with his scythe toward a representation of
the Holy Family. Symbols of art, religion, and the peaceful, pastoral life
are intermingled with the text. At the bottom of the text a farmer plows
over a field of human skeletons, symbolic of the ageless cycle of life, death
and rebirth of nature and nations.

P.N.

PACTE DE LA SOCIÉTÉ DES NATIONS

AVEC ANNEXE

ÉDITION NUMÉROTÉE CONFORMÉMENT À LA RÉSOLUTION ADOPTÉE À LA SEPTIÈME SESSION ORDINAIRE DE L'ASSEMBLÉE, LE 21 SEPTEMBRE 1926, ET CONTENANT L'ARTICLE 6 AMENDÉ EN VIGUEUR À PARTIR DU 13 AOÛT 1924, LES ARTICLES 12,13 ET 15 AMENDÉS, EN VIGUEUR À PARTIR DU 26 SEPTEMBRE 1924, ET L'ARTICLE 4 AMENDÉ EN VIGUEUR À PARTIR DU 29 JUILLET 1926

LE 10 DÉCEMBRE 1930

PAVEL TCHELITCHEW (1898–1957)

66. *Hide and Seek: A Study*, 1941

Brush and india ink on paper

8½ × 11 inches

Signed, dated and inscribed lower right: *To dear Edward for Christmas and
New Year with love Pavlin 1941*

PROVENANCE
Gift of the artist
Mr. Edward James, New York

PAVEL TCHELITCHEW was born in Moscow in 1898 of
aristocratic parents. When the Revolution left the city in political
turmoil, the family fled to Kiev where Tchelitchew attended the
Academy, studying with Alexandra Exter, a former pupil of Fernand
Leger. Exter worked on theater set designs and posters in a Cubist-
Constructivist style. Tchelitchew moved to Paris in 1923, where he
renounced his former Cubist manner and began to paint landscapes and
portraits. In the mid–1920s, the artist started to show his first
experiments with images of exaggerated faces or figures. At the same
time, he was designing sets for Diaghilev ballets.

In 1930, Tchelitchew was given his first major show in America, at
the Museum of Modern Art, which was followed by his emigration to this
country four years later. His masterpiece, *Hide and Seek* (1942; Museum
of Modern Art, New York), exemplifies Tchelitchew's mature subject—a
metaphoric web, suffused with drama and emotion, of exaggerated
children's heads, disembodied hands and trees.

This ink study for *Hide and Seek* carefully delineates the head of the
child from the left foreground of the painting. Although the child's game
of hide-and-seek, depicted as a childhood idyll, had been a popular
subject for late nineteenth century painting, Tchelitchew has transformed
the subject, so that here it represents twentieth century anxiety. The
drawing of the head, which fills the space of the study, captures the spirit
of the large painting in its tangled mass of lines weaving subtly-shifting
images characteristic of surrealist metamorphosis. Small figures appear
and disappear from the shape of the baby forming the eye, nose and
mouth to the baby at the base of the skull. The agitated lines underscore
the tension in the drawing which captures something of the American
mood on the eve of the nation's entry into World War II.

P.N.

To dea[r]
Edward
for
Christmas
and
New Year
with
love
Pavlik
1941

JOHN HENRY TWACHTMAN (1853–1902)

67. *Portrait of Elsie*, ca. early 1890s

Pastel on pumis paper
16 × 12 inches

PROVENANCE
The artist
Violet Twachtman Baker (granddaughter of the artist), New York
Martha Baker (daughter of Violet Baker), Italy
By descent through the family

AMERICAN IMPRESSIONIST John Henry Twachtman was born in Cincinnati. Studying in Munich in the mid-1870s and Paris in the early 1880s, Twachtman was at the forefront of American avant-garde art movements throughout his career. He settled in Greenwich, Connecticut, in 1889, where he developed a style influenced by French Impressionism yet tempered by his personal response to nature and his individual technique. Involved with many important art groups, Twachtman was a member of the Society of American Artists, the Tile Club, the Society of Painters in Pastel and the Ten American Painters.

Twachtman began to experiment with pastels in the mid-1880s. By the end of the decade, he had mastered the medium, developing a light and spontaneous touch with which he created fresh and intimate glimpses of nature. He made a limited number of figural renderings in pastel, almost all of which portray members of his family. This portrait from the 1890s depicts Elsie, the artist's second daughter, born in 1886.[1] Using very simple means, Twachtman presents a lively portrait. A look of reflection and amusement is evident in the face of his sitter. The treatment recalls Twachtman's training in Munich in the late 1870s which had stressed a bold, realist approach. However, rather than rendering the work in the dramatic, bravura style in which he had worked during his Munich period, Twachtman uses a delicate and minimal application of his medium, softly indicating the features of his daughter and suggesting, with a few sketchy notations, the shape of her dress and the reflections of light on her shoulders. The tone of the paper is the basis for the color scheme, setting out a soft spatial context for the figure and unifying the composition. This pastel may have had special meaning for the artist, as a memento of Elsie, who died in 1895 at the age of nine. The work remained in the possession of a family member until 1988.

L.P.

1. Two of Twachtman's pastels portraying Elsie are currently known, both are in private collections.

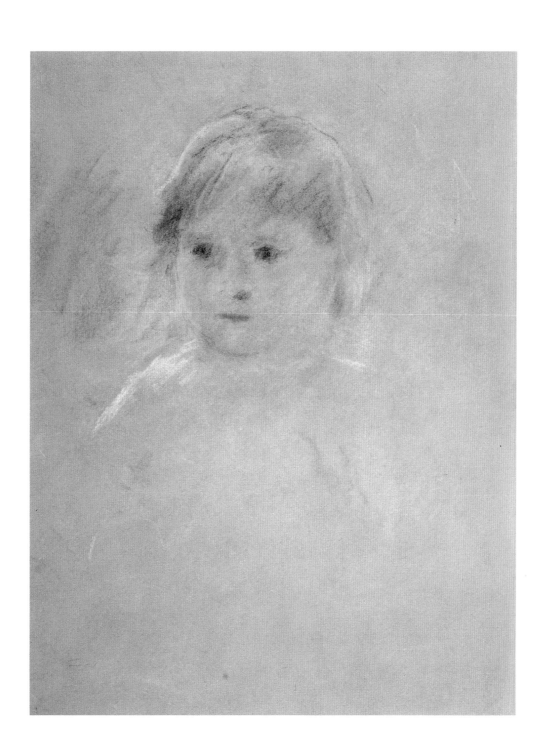

ABRAHAM WALKOWITZ (1878–1965)

68. *Bathers in a Quarry*, ca. 1930s

Watercolor on paper
17 × 22 inches
Signed lower left: *A. Walkowitz*

PROVENANCE
Dr. Davis, Brookline, Massachusetts
Estate of Dr. Davis, ca. early 1960s

ABRAHAM WALKOWITZ was in many ways the conscience of the early twentieth century American avant-garde. In his unswerving devotion to the tenets of European modernism, which he served in his work and through the promotion of his aesthetic theories, Walkowitz had no equal among American artists.

Bathers in a Quarry shows the degree to which he found inspiration in the works of Cézanne and Matisse, revealing especially his interest in their simplifications of form. Walkowitz would have had ample opportunity to study the achievements of Cézanne and Matisse first hand during the time he spent in Paris between 1906 and 1909. Those were the years marking the peak of Cézanne's influence and the emergence of Matisse, and like every artist who came to Paris with the goal of steeping his or her sensibilities in the latest developments, Walkowitz was known to frequent the exhibition rooms of the annual salons, the Salon of the Independents and the Autumn Salon, which were important showcases for the works of both artists.

From Matisse's *Joy of Life* and *Le Luxe* comes the idyllic feeling that pervades the sensitive and rather chaste treatment of the bathers in the Walkowitz work. Like the Matisse figures, they appear to inhabit a world apart from the commonplace. However, the work's tension-filled structure comes mainly from Cézanne, especially in the way the figures are modeled to emphasize contours as well as mass, and the way in which landscape is rendered using color and line equally to bring out both flatness and volume.

R.C.

MAX WEBER (1881–1961)

69. *Friends*, 1916

Gouache and charcoal on paper
18¼ × 24 inches
Signed and dated lower right: *Max Weber 1916*

PROVENANCE
[Kennedy Galleries, New York]
Mr. and Mrs. Irving Levick, Buffalo, New York
[Kennedy Galleries, New York]
Jacob Schulman, Gloversville, New York
Estate of Jacob Schulman, Gloversville, New York

EXHIBITED
New York, The Downtown Gallery, *Max Weber / The Figure in Retrospect
 1906–1958*, November–December, 1958, cat. no. 12.
Boston, Boston University Art Gallery, *Max Weber Memorial Exhibition*
 (organized by the American Academy of Arts and Letters), March,
 1962, cat. no. 98.
New York, The Jewish Museum, *Personal Vision: The Schulman
 Collection of 20th Century American Art*, July–October, 1985,
 illustrated.
South Hadley, Massachusetts, Mount Holyoke College Art Museum,
 Personal Vision: The Schulman Collection, January–February, 1986.

LITERATURE
Art Lover, Vol. 3, No. 5 (1935–1936), p. 69 illus.
"Max Weber–Painter," *The Index of Twentieth Century Artists*, 4,
 (November, 1936) 351.

MAX WEBER, A PIONEER modernist, was born in Bialystok, Russia, in 1881. He emigrated with his family to the United States in 1891 and settled in Brooklyn. He enrolled at the Pratt Institute in 1898. The next two years were spent studying under Arthur Wesley Dow, who was known for his openness toward avant-garde art. Under Dow's tutelage, Weber was introduced to Japanese and primitive art forms as well as to the work of such Post-Impressionists as Paul Gauguin.

From 1901 until 1905 Weber held various teaching positions, all the while saving money for additional study in France. In 1908, he studied briefly with Matisse, and he was strongly influenced by the master's arbitrary use of color and distorted forms. He also familiarized himself with the Cubism of Picasso and Braque, and the Orphism of Robert Delaunay. Weber returned to New York in 1909. He immediately painted a number of works in which were combined the intense colors of fauvism with primitive figural elements.

Friends is from a series of Cubist paintings produced in 1916, the year of his marriage. Many of his paintings of this period are conversation pictures representing courting couples, and they are much more joyful works than his monumental city paintings of the previous year. *Friends* represents a summation of the images of courting couples, for this fantasy image presents a single male figure on a bed with five nude female figures in a variety of poses.

Although it is the most sexually suggestive of Weber's Cubist works, *Friends* is the descendant of the nude figures that Weber had been painting since his study with Matisse. It is also the precursor for a large series of nudes reminiscent of Cézanne that Weber produced during the 1920s. *Friends* marks a return to the figural tradition that Weber abandoned during the three years he concentrated on images of the city.

Although Weber produced oil paintings in 1916, the majority of his work of that year was in watercolor, pastel, and gouache. The formal structure of *Friends* is characteristic of Weber's use of Cubist construction, although he depicts faces more completely here than in earlier works. The muted tonalities are typical of the colors in the intertwined figures produced from 1916 to 1919.

The theme of *Friends* represents a culmination of the courting couples who have been brought to bed. The male figure at the left, with his right foot balancing on the floor and his right arm raised over his head, appears to be contemplating his sole lover in the guise of a series of dozing, yawning, stretching and sleeping figures. The similarity of the faces and long flowing black hair of the five figures suggests that they may represent the same woman. Characteristically, the compact figures are pressed toward the foreground of the composition, bringing the viewer into close contact with them.

P.N.

JAMES A. McNEILL WHISTLER (1834–1903)

70. *Venetian Courtyard*, ca. 1879

Pastel on brown paper
11⅞ × 8 inches

PROVENANCE

[With Stephen Sommerville, London, England, October, 1974]
Mrs. J.E. Morgan
[Christies, London, England, July 18, 1975, Lot No. 15, as *Venetian
 Courtyard*]
[Thomas Agnew and Sons, Ltd., London, England, 1975]
[Sotheby's, New York, Sale No. 4971, December 2, 1982, Lot No. 13 as *A
 Venetian Courtyard*]
[Coe Kerr Gallery, New York, 1982]
Private Collection, Los Angeles, California

EXHIBITED

Melbourne, Victoria, Australia, *Exhibition of Old Master Drawings,
 Watercolors and Prints from Thomas Agnew and Sons, London*,
 October–November, 1976, no. 20
Coe Kerr Gallery, Inc., New York, *Americans In Venice 1879–1913*, 19
 October–16 November 1983; The Boston Athenaeum, Boston,
 Massachusetts, 23 November–18 December 1983, pp. 27 (illus.), 88
 (cat. no. 6), as *Venetian Courtyard*, c. 1880
Coe Kerr Gallery, Inc., New York, *American Impressionism II*, 19 May–23
 June 1989, fig. 45 (illus., n.p.), as *A Venetian Courtyard*

NOTE

This work will be included in the forthcoming catalogue raisonné of
 Whistler's pastels, drawings and watercolors by Margaret F.
 MacDonald, Honorary Research Fellow, Hunterian Art Gallery,
 University of Glasgow, Glasgow, Scotland, to be published by Yale
 University Press.

JAMES A. McNEILL WHISTLER was left financially drained
 after the famous 1877 trial in which he brought suit for libel against
 John Ruskin. Thus the commission for a set of twelve etchings of the
 city of Venice from the Fine Arts Society, a London gallery, came as a
welcome offer of relief. Leaving London, where the important American
expatriate had been living since 1859, Whistler departed for Venice.

During the eleven months he spent in Italy, Whistler produced, in
addition to etchings, about one hundred pastels which are among his
finest works. In Venice, he formulated an individual pastel technique. He
turned away from his previous style, which had involved building up an
image with thick layers of chalk, in favor of using colored papers and
incorporating their tones into his design schemes, thus allowing pigment
and ground to interact.

In *Venetian Courtyard* Whistler uses his understated technique to
great effect. A light framework of charcoal lines articulates the façade of a
Venetian building. Eliminating incidentals, Whistler produces a vignette
of the scene (a favorite device in his Venetian works). The work can
almost be read as an abstract composition. The outer surface of the
building becomes one with the flatness of the picture plane. Filling the
delicate, weblike armature with touches of pure color, Whistler creates a
rich contrast with the deep brown of the paper. He renders the scene
with a casual spontaneity that nonetheless records his observations with
accuracy and precision: steps leading down from the lower arcade
disappear at the water level of the canal; the sparing depiction of a figure
on the balcony of a neighboring structure conveys the density of the
Venetian cityscape. Yet Whistler had little concern with a factual
presentation of the scene. *Venetian Courtyard* is the expression of an
unusual affinity between an artist and his subject. As Whistler wrote of
Venice to his mother: "The people with their gay gowns and hand-
kerchiefs—and the many tinted buildings for them to lounge against or
pose before, seem to exist especially for one's pictures—and to have no
other reason for being!"[1]

L.P.

1. James McNeill Whistler, Venice [n.d.] to his Mother [London], Archives, Freer
Gallery of Art, Washington, DC, folder no. 176.

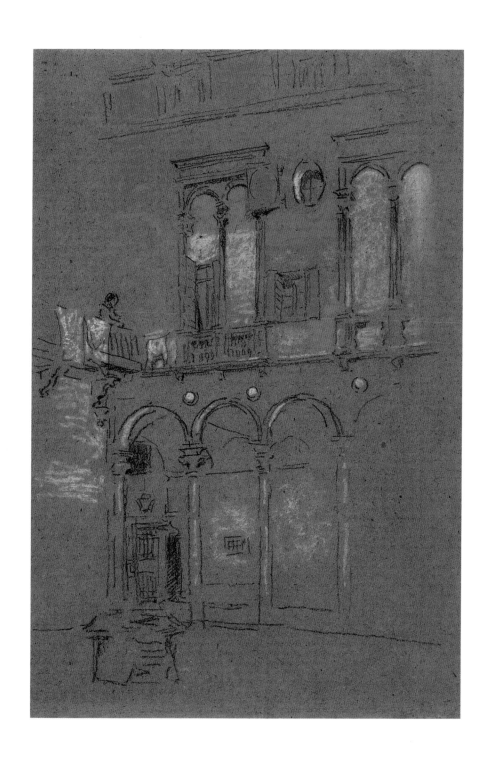

JOHN WHORF (1903–1959)

71. *Swan Boats*, ca. mid–1950s

Watercolor on paper
14½ × 21½ inches
Signed lower right: *John Whorf*

PROVENANCE
Private Collection, Cambridge, Massachusetts

EXHIBITED
(possibly exhibited at) Vose Galleries, Boston, *Watercolors by John Whorf*,
 15 November–4 December 1948, no. 26 as *Swan Boats, Public
 Garden*.

JOHN WHORF WAS one of the outstanding watercolorists of the
twentieth century. He grew up in the artistic environment of
Provincetown, studied at the Boston Museum Fine Arts School with
Max Bohm and Charles Hawthorne and at the Académie Colarossi in
Paris, and by the age of twenty-three was already showing his watercolors
and earning considerable praise.

Like Winslow Homer and John Singer Sargent, two artists with
whom his work has often been compared, Whorf was able to exploit the
watercolor medium fully. Through a career spanning more than three
decades, he continued to develop an individual and eye-dazzling
technique using dry brush and wet areas, transparent washes and opaque
color.

Boston was a favorite subject for Whorf, who was known also for his
landscapes and seascapes of New England. *Swan Boats* is one of the most
striking of his Boston views.

The work is an appealing depiction of one of the most beloved
institutions in the city of Boston, the Swan Boats, which for a small
charge have been taking people around the lagoon of the Boston Public
Garden since 1877. Whorf has captured the enjoyment of this ride
through the park's most beautiful section, in the sparkling light that filters
through the surface produced by his subtle rendering of shadows.
Through the poses of the figures, Whorf shows us how people behave in
such a setting, the range of responses: some sit quietly in contemplative
poses, while others are restless, more interested in their fellows than in
nature. *Swan Boats* is a wonderful picture of the American family at
leisure, an idyll of a relatively tranquil period.

 R.C.

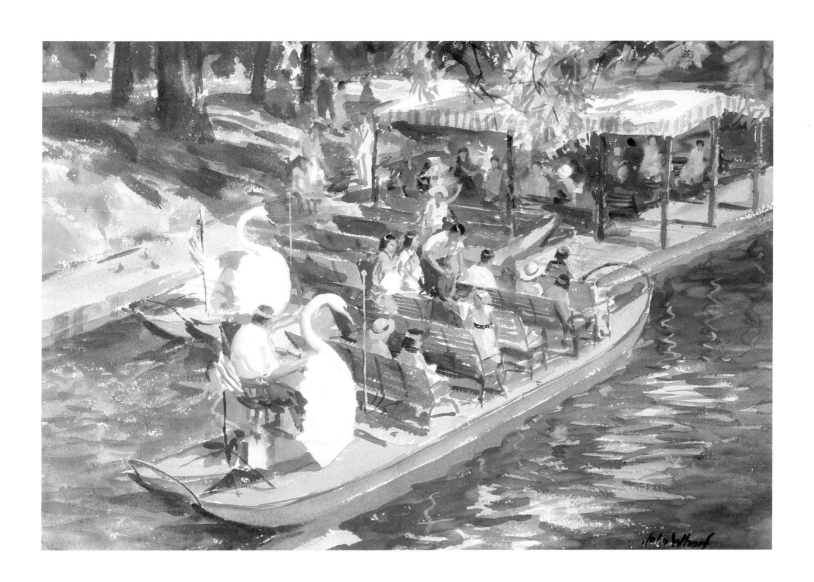

THEODORE WORES (1858–1939)

72. *China Girl in Flowered Headdress*, ca. 1884

Pastel on pumis paper
19½ × 15½ inches
Signed center right: *Theo. Wores*

PROVENANCE
Private Collection, London

ONE OF THE FIRST American artists to fully explore the
Oriental subject, San Francisco born Theodore Wores received
his formal training at the Royal Academy in Munich in the
late-1870s. Under the instructors Ludwig von Loefftz and Alexander von
Wagner, he learned a solid figural style and academic finish, but it was
during his informal tutelage with Frank Duveneck that he acquired a
virtuosity with paint and technique.

While associated with "the Duveneck boys" in Venice, Wores was
inspired by the exotic enthusiasms of James McNeill Whistler. His first
subjects when he returned home in 1881 were the everyday scenes of San
Francisco's Chinatown—the fishmongers, the shopkeepers and the actors
in the traditional theater. Several of Wores' students were Chinese, and
one of them, Ah Gai, became his personal envoy within the district.

Subsidized by the sale of his early works, Wores was able to spend
two years in Japan, beginning in 1885. He then took both the Chinatown
and Japan paintings on tour to New York, Boston, Chicago, Washington,
D.C. and finally London (1889), where he was welcomed by his old
friend, Whistler. The works were an overnight success. "The curious . . .
faces, the strange rites, the gorgeous colours, all powerfully fascinated
him," wrote one critic," and he painted them as he saw them, with
vigorous richness and fidelity."[1]

China Girl in Flowered Headdress is a pastel of this early period,
alive with the exoticism noted by the reviewers. The young girl stares out
at us, fully aware of her role in a unique culture. Wores' adept modeling,
equal to his virtuosity in oil, exhibits all the textural possibilities of the
pastel medium as well as its depths of color. Glowing tints of orange, rust,
blue and velvety black bring the remarkable presence and hidden
psychology of the child to life.

China Girl in Flowered Headdress exhibits the important transitional
phase of Wores' art in the mid-1880s, a period in which he retains the
solidity and technical prowess of his Munich training while also beginning
to show the Impressionist tendencies which would later figure in his
brilliant landscapes.

L.B.

1. Lew Ferbrache, *Theodore Wores: Artist in Search of the Picturesque* (Alameda,
California: David Printing Co., 1968), p. 32.

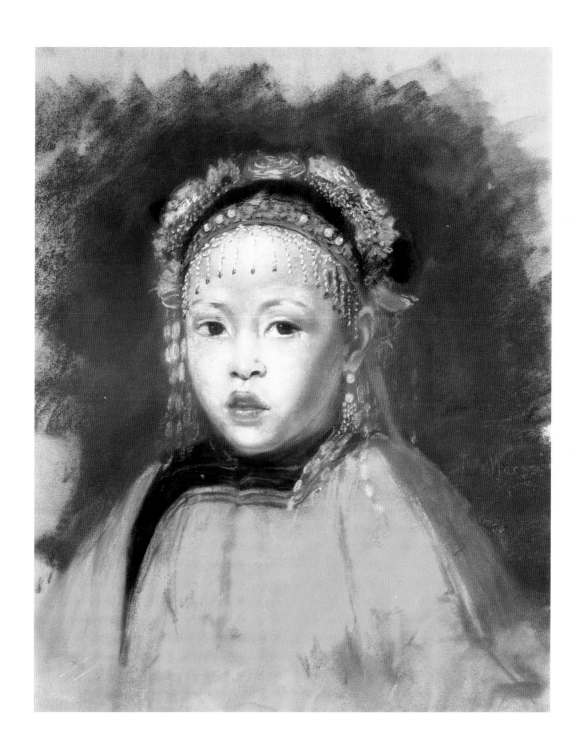

ANDREW WYETH (B. 1917)

73. *Deep Woods*, ca. 1970s

Watercolor on paper
22½ × 29½ inches
Signed lower left: *Andrew Wyeth*

PROVENANCE
Frank Fowler, Tennessee, 1970's
Mrs. Genevieve Schultz, 1986
Private Collection, Washington, DC

NOTE
A copy of Andrew Wyeth's letter accompanies the watercolor.

ANDREW WYETH, whose poetic, meticulously-rendered images have made him one of America's most popular contemporary artists, is also regarded as the foremost exponent of the realist tradition today. A loner who works independently of mainstream trends, Wyeth has remained faithful to a naturalistic depiction of the world around him.

Born in Chadds Ford, Pennsylvania, Wyeth received his earliest training from his father, the illustrator N. C. Wyeth. However, for the most part, Wyeth developed his skills on his own, once stating that he "worked everything out by trial and error." He was influenced also by the realism of Winslow Homer and Thomas Eakins.

Wyeth had his first solo exhibition in 1937, at the Macbeth Gallery in New York City. The show, which consisted of a display of colorful watercolor renderings of Maine, sold out within twenty-four hours. Taken aback by the immediacy of his success, Wyeth decided to focus his creative energies on an art of deeper substance. He subsequently turned to more serious subject matter, exploring the underlying psychological make-up of his subjects as well as the universal themes of nature. Since 1939, Wyeth has worked almost exclusively in egg tempera, using a subdued, low-keyed coloration.

In 1940 Wyeth married Betsy Merle James, who introduced him to her childhood friend, Christina Olsen, the woman portrayed in his masterpiece *Christina's World* (1949; Museum of Modern Art, New York). Wyeth went on to paint numerous renditions of the Olsen family, residents of Cushing, Maine. Another frequently depicted group was the Kuerner family, Wyeth's neighbors in Chadds Ford. Wyeth's iconography also includes young children, blacks, old houses, lonely beaches and portraits of sober New Englanders.

Wyeth's attachment to the watercolor medium began in 1933, when the young artist saw a group of colorful watercolors by Homer. Since that time, watercolor has remained one of Wyeth's preferred mediums, allowing him, as he said, to "express the free side" of his nature.

Deep Woods is a fine example of Wyeth's highly personal response to nature and of his mastery of the "dry brush" technique (where the "wetness" is derived from the pigment alone). According to a letter written by the artist in September 1977, the work was painted near his summer home in Cushing, Maine.[1] Although Wyeth does not say exactly when it was completed, he does say something of the season: "Ferns have always fascinated me in the late Fall." The scene consists of a close-up view of a dark, verdant forest interior. The foreground is dominated on the right by a large rock. Growing near its base, on the left, are a number of ferns, several of their feathery green fronds tinged with pale tans, rusts and browns. Their sharply delineated forms contrast strongly with the background, where leaves, rocks, lichen, moss and earth intermingle in a rich aura of dark greens and greys.

By choosing to focus on a small segment of nature, Wyeth takes an approach seen also in the work of the photographer, Edward Weston, who also found meaning in the isolation of details. Wyeth combines this aesthetic with a painterly technique that conveys a mood of immediacy. Indeed, the small bits of twigs embedded in the pigment assures us that the work was painted outside rather than in the studio. The seemingly random spattering of paint across the area of rock heightens the sense of spontaneity and evinces the moments of creation.

In *Deep Woods*, Wyeth gives us what at first appears to be a very ordinary patch of forest green. However, through the process of fragmentation, which gives an abstract quality to the work, Wyeth takes his subject beyond the realm of the ordinary, transforming it into an emblem of feeling and an invitation to meditation. This approach, where realism is combined with an evocative and highly personal view of nature, has inspired many of today's younger representational painters, especially those who have also chosen watercolor as a primary means of expression.

C.L.

1. Andrew Wyeth, Thomaston, ME to Mrs. Ayers, 19 September 1977, Andrew Wyeth Documentation File, Spanierman Gallery, New York.

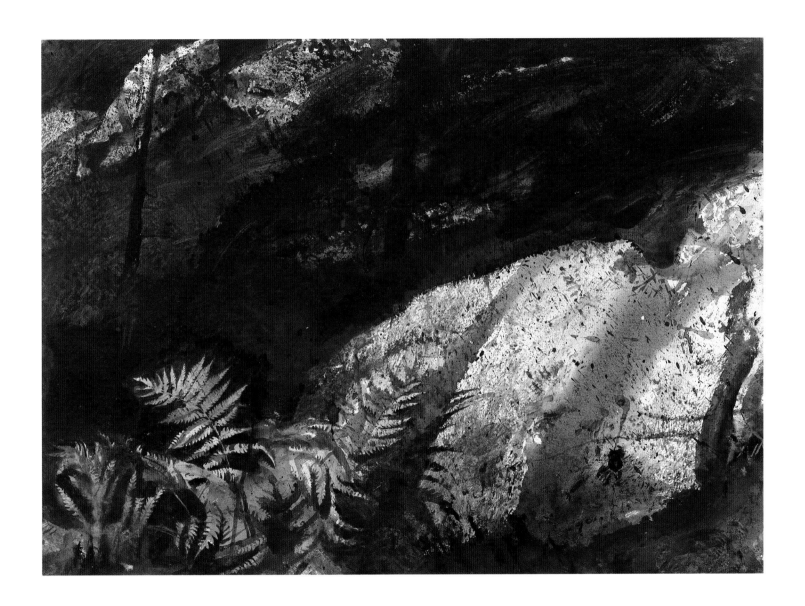

KARL YENS (1868–1945)

74. *Dignity of the Tree*, 1929

Watercolor and charcoal on paper

11¼ × 15 inches

Signed and dated lower left: *Karl Yens / 1929*

Inscribed on mat, verso: *Dignity of the tree / Descanso San Diego
County / California*

PROVENANCE
Private Collection, California

B ORN IN GERMANY, Karl Yens studied in Berlin and Paris
before emigrating to the United States in 1901 at the age of thirty-
three. An established muralist in Europe, he continued to work
on murals and decorative projects once he arrived in New York, receiving
commissions in various cities. By 1910 he had worked his way to
California and settled in the Pasadena area. It was in California that the
second phase of the artist's career began, as he devoted himself to easel
paintings and watercolor. Yens was later a pioneering member of the
legendary Laguna Beach artists colony, which was the focal point of
artistic activity for the Los Angeles area.

Yens did landscapes, portraits, still lifes and genre subjects, and he
was a favorite of the growing crowds that came to attend the annual
exhibitions of The Painters and Sculptors of Southern California and The
California Watercolor Society, two of the artists' associations to which he
belonged. In the lively literature devoted to the burgeoning California art
scene, found in the art pages of the *Los Angeles Times* and in national art
periodicals of the period, Yens and his landscapes are frequently singled
out for special mention.

The same qualities that won Yens high praise half a century ago
appear no less impressive today. In *Dignity of the Tree* we see how his
spiritual attitude toward life does indeed "act as driving power behind his
brush in quite naturalistic subjects."[1] Looming large with a grand crown
of leaves and mighty trunk, the tree seems to embody the generative
forces of the earth and is thrust forward for us to appreciate, a powerful
symbol of the beauty of nature's creations.

Yens recalls Winslow Homer in the brilliant effects he achieves with
delicate washes, for instance in the area in the lower left showing leaves
and trunk against near and distant ground. The use of charcoal to give

added relief is an element of Yens' technique that anticipated the
California style of watercolor that emerged in the 1930s with the
graphically bold treatments of a younger generation of artists led by
Millard Sheets and Barse Miller.

R.C.

1. "Yens seen as Primative in an age of Practicality," *Los Angeles Times*
(26 February 1933): 4.

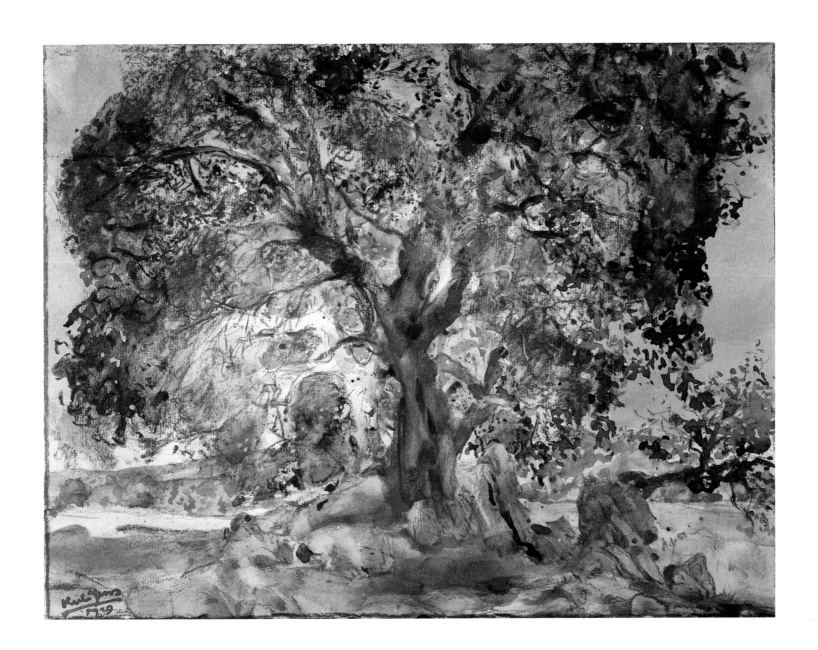